POSTCARD HISTORY SERIES

# *Rehoboth Beach*
## IN VINTAGE POSTCARDS

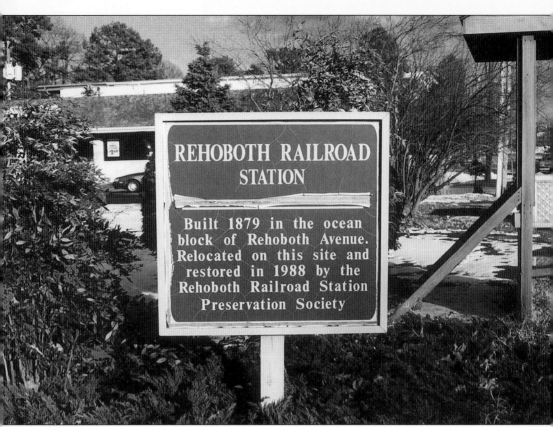

**RAILROAD STATION SIGN.** The railroad was a major form of transportation for the small oceanside town. It came to Rehoboth in 1878, providing passenger and freight service, which created a need for a station. In 1884, the railroad extended to the ocean block of Rehoboth Avenue, and then to Laurel Street in 1891. By 1928, passenger service was discontinued. As the sign here states, the station was re-built in 1988 by the Preservation Society. (Courtesy of Nan DeVincent-Hayes.)

POSTCARD HISTORY SERIES

# *Rehoboth Beach*
## IN VINTAGE POSTCARDS

*Nan DeVincent-Hayes, Ph.D and Bo Bennett*

ARCADIA

Published by Arcadia Publishing,
an imprint of Tempus Publishing, Inc.
2 Cumberland Street
Charleston, SC 29401

Printed in Great Britain.

Library of Congress Catalog Card Number: 2002102037

For all general information contact Arcadia Publishing at:
Telephone 843-853-2070
Fax 843-853-0044
E-Mail sales@arcadiapublishing.com

For customer service and orders:
Toll-Free 1-888-313-2665

Visit us on the internet at http://www.arcadiapublishing.com

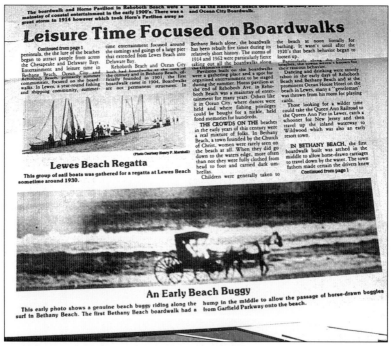

**NEWSPAPER.** Even in its early years, Rehoboth and its surrounding towns were busy little boroughs. Rehoboth soon became known as "The Nation's Summer Capital" as more and more urbanites discovered the quaint hamlet. Activities in the town abounded as the population burgeoned. This clipping includes reminiscences such as an early beach buggy in Bethany, a regatta in Lewes, and the famous Horn's Pavilion in Rehoboth. (Courtesy of Rehoboth Beach Public Library.)

# CONTENTS

# DEDICATION

(*left*) **ALAN BROADBENT**. Born and raised in Dewey and the Rehoboth area, Alan knows the seaside towns well. While his mother worked in Philadelphia, he lived with his grandparents, the Ammons, until 1952. When his mother returned, she took over managing the Royal Surf Motel in Dewey, which became one of Alan's favorite places before he and his mother moved to Florida. Alan says he looks upon the Delaware coastal towns with a sense of nostalgia because of its family, hometown atmosphere. He recalls such minute details as having been driven to school by the owner of the Avenue Restaurant in her Pontiac Convertible. A postcard and weapons collector of many years, Alan and his fiance, Faye Nadia Parson, live in Florida. He has served his country as a Senior Master Sergeant in the United States Air Force for 21 years.

(right) **JOHN JACOB.** A former attorney and longtime resident of Salisbury, Maryland, John is a noted historian and postcard collector. He takes great pleasure in digging up obscure facts and putting them together in publication form. He has scoured nearly all of the lower eastern shore interviewing sources and taking pictures. John particularly enjoys penning pictorial histories, which include *The Postcard History Series: Salisbury, Maryland*; *The Postcard History Series: Somerset County*; *The Postcard History Series: Wicomico County and Delmar*; and *The Postcard History Series: Worcester County*. He also published *Images of America: Ocean City, Volume I* and *Images of America: Ocean City, Volume II* with Nan DeVincent-Hayes, Ph.D for Arcadia Publishing. John is currently working on several other pictorial histories.

# OVERVIEW

The resorts in the coastal towns of Delaware are among the most popular and well known in the country. This book takes a close look at the fun and sun of Rehoboth and its surrounding "quiet resorts," which include the following: Fenwick Island, Bethany Beach, Dewey Beach, and Lewes. Rehoboth is Delaware's version of famous Ocean City, boasting similar boardwalks, concession stands, colonial and modern hotels, and amusements, but differs somewhat with its quaint tree-shaded streets, and almost-white, coarse, sandy beach. The expansive retail outlets not far from downtown Rehoboth are major attractions because of their popular clothing stores. The resort is not only celebrated as the "Nation's Summer Capital," but also as a vacation area that appeals to a diverse group of people—retirees, college students, and fleeing urbanites wanting to leave the hustle and bustle of Philadelphia, Baltimore, D.C., and many other cities in all 50 states. Visitors also come from other countries and return year after year. Rehoboth offers a myriad of activities that include a tour of the wooden model of the old Cape Henlopen Lighthouse, which was destroyed when it toppled into the roaring ocean during a 1926 storm. Tourists are also kept busy dancing, fishing, sailing, swimming, eating, and even hunting.

The town of Rehoboth is very simply laid out in a fan shape. The entrance is at the base of the fan where the tabernacle once was. On the west end, side avenues are named after religious denominations; on the east end, they are named after cities and states. Streets (not avenues) run north-to-south and begin at the ocean with First Street up to Fifth Street. Lake Avenue is named after Lake Gerar, which sits between Avenue and the end of the city line.

Dewey Beach, Bethany Beach, and Fenwick Island are much quieter than Ocean City and offer a host of attractions, along with a cherished beach, and an environment of charm and enchantment. Bethany Beach takes pride in its arts festival during the shoulder season as well as its museums and seashore parks and recreation. The Cape May-Lewes Ferry (about 20 miles from Rehoboth) is popular for shuttling tourists back and forth from the resorts to New Jersey, where many try their hand at the casinos. Bethany's colorful history reflects Christian roots originated by a missionary society, and its prime location makes the surrounding resorts easily accessible.

Rehoboth's beautiful location and its quiet resorts encourage urban dwellers to take a break from city life and relax on the beach. Baltimore, D.C., Philadelphia, Harrisburg, Lancaster, Trenton, Norfolk, and Wilmington are between 100 and 170 miles away; New York City is about 220 miles away; Pittsburgh is 347 miles away; and Cleveland is about 460 miles away. Along with sunbathing and swimming, the resorts offer surf-fishing tournaments, bike tours, "Exercise Like the Eskimos" (see page 94), golf, various balls and festivities, and a host of other happenings. Delaware's coastline is lined with interesting, entertaining, and historical beaches to visit. If you choose one, you'll most likely find yourself scooting up and down the seacoast enjoying all of them.

<div align="right">Nan DeVincent-Hayes, Ph.D and Bo Bennett</div>

# ACKNOWLEDGMENTS

Numerous people and sources have helped us put this book together. We appreciate the interviews, mail, phone calls, and photographs. Not only do we thank postcard collectors Alan Broadbent and John Jacob, we are grateful for those on the "sidelines" who rooted us on: our editors Christine Riley and Carolyn Lemon, Bo's son Stephen, Nan's daughters Marta and Brynne, and her husband James, who put much time into the technical aspects of this book.

If we have overlooked anyone, know that we thank you too, along with the following who have given of their time: Quig Bennett, Valerie Bennett, Cathy Phillips, Valerie Bailey, Heather Cole, Nicole Phillips, Christine Bailey, Lauren Bailey, Tatiana, Diana Steward, Padburys, David S., Kelly Fleming, Effie Cox, William Lewis Bennett, David Lee, Hunter Cox, Chelsea Cox, Rick Gillis, Karen Bates, Marilyn Hacket and the Rehoboth Beach Public Library, Matt Turling and Jerry Sipes, George Yasik, Mrs. John F.W. King, Ms. Irene Simpler of the Anna Hazzard Museum of the Historical Society of Rehoboth Beach, Carol Lingo of St. Edmond's Parish, Kathy of Camp Rehoboth, Pastor Mike Hurley of United Methodist Church, Donna Benge of Oak Grove Court, Gail R. Studavant of Westminster Presbyterian Church, Gina Charles, Paula Price, Carol Everhart, Julie Brewington, Chad Moore, Don Derrickson, Jeff Lattinville, Bob Feeney, Ron Barrows, Abby Schaefer, Lanman Ashley of the Rehoboth Beach Police Department, Kent Buckson (Captain of the Rehoboth Beach Patrol), Tom Summers of the Delaware Public Archives, Gregory Ferrese (City Manager of Rehoboth Beach), Tim Foley of ReMax, Rehoboth Beach Chamber of Commerce, Bethany of the Fenwick Chamber of Commerce, Mrs. Thoroughgood, John Townsend Tubbs, and Gary Stabley.

# One

# THE QUIET BEACHES

## SNIPPETS AND SNAPSHOTS

*Resorts like Ocean City, Maryland, Chincoteague, Virginia, and Rehoboth, Delaware get much exposure because they are larger, noisier, and more commercialized, while the smaller but equally valuable resorts go unnoticed by most tourists. These are the quiet resort towns of Fenwick Island, which includes Bethany Beach, Dewey Beach, and Lewes. These beaches offer a nice alternative to the busy tourist areas with their quaint villages, cobblestone streets, and warm hospitality.*

*The Fenwick Island area includes Ocean City and Bethany Beach. A small region, it marks the coastal boundary between Maryland and Delaware, but most tourists are not aware when they move from the northern end of the Maryland shoreline into the southern tier of Delaware's coast. Fenwick Island is made up of sandy beaches, commercial areas, various lodging options, golf courses, restaurants, and historical attractions like the Shipwreck Museum. Because most tourists aren't aware of this gem, local Delmarvans (a name derived from the combination of Delaware, Maryland, and Virginia) love to vacation at Fenwick Island during the shoulder and prime seasons instead of dealing with Ocean City and its eight million visitors tromping in and out of the 5,000-permanent-resident town over the short course of a summer. Fenwick Island boasts clean beaches, non-commercial taxes, and an old-town flavor.*

*Bethany Beach is just north of Fenwick and south of Dewey and Rehoboth. Between Bethany Beach and Dewey is the Indian River Inlet, which runs into Rehoboth Bay. With only a few thousand year-round residents, Bethany holds its own when it comes to summer tourists, with pavilions lining the original boardwalk built around 1803. It was founded by Washington D.C.'s Disciples of Christ in 1901 and its first building was a tabernacle. The 1901 trip from D.C. to Bethany was a grueling two-day railroad, boat, and wagon affair requiring the endurance of mosquitoes, storms, and dirty trains. The powerful 1962 blizzard/hurricane flattened the village, but the loyal residents promptly rebuilt Bethany into the thriving seaside town it is today.*

*Dewey Beach benefits from its proximity to Rehoboth because tourists often visit both areas. The beach features breathtaking sunsets over the Indian Bay Inlet, cozy bed-and-breakfast inns, fine hotels, restaurants, and numerous surf and sand activities. Located south of Rehoboth and north of Bethany, Dewey has the Atlantic Ocean on its east and the Little Assawoman Bay on its west. Dewey is also home to the highest sand dune between Cape Cod and Cape Hatteras, which is 80 feet above the shoreline.*

*Like Dewey Beach, Lewes also benefits from being close to Rehoboth and enjoys the immense popularity of Cape May, New Jersey as well, because both full-time residents and tourists take the 70-minute ferry ride to Atlantic City's casinos, parks, beaches, and zoo. Lewes is dormant during the off-season and seems relatively bucolic but is actually the host of many popular local events, including the Merchants Hospitality night, Preview Reception Art Show and Sale, a Christmas tour, parade, and concert, a tree lighting, and its annual "Exercise Like the Eskimos"—all in December. Begin your Delaware coastal exploration from Fenwick Island and work your way up to Lewes.*

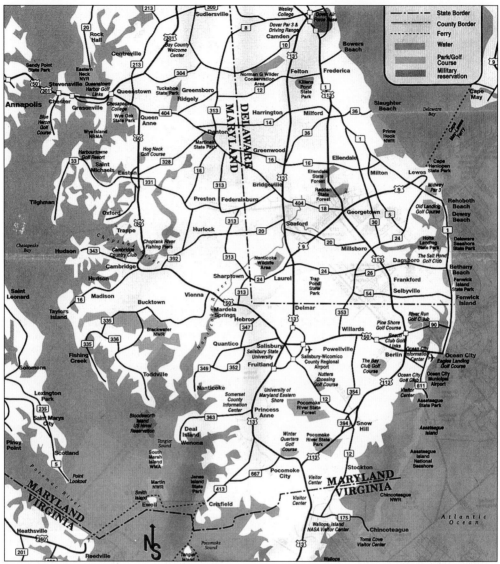

**DELMARVA MAP**. This map of Delmarva displays all of the major resorts along the coast of the Atlantic that are pertinent to this book. Notice the ferry crossing at Lewes and the numerous state parks amid the resorts. The beach resorts covered in this book are in Sussex County, of which Georgetown is the county seat. All of Sussex County and its 11 cities have only about 140,000 residents out of a state population of about 760,000.

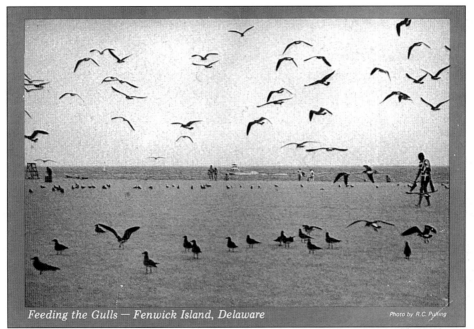

*Feeding the Gulls — Fenwick Island, Delaware* <span style="float:right">Photo by R.C. Pulling</span>

**GULLS GALORE**. This *c.* 1970 postcard shows a quiet beach with a flock of various seagulls. Great Black-backed gulls, Black-headed gulls, Laughing gulls, and Herring gulls are all indigenous to the Atlantic Ocean area. Although Fenwick Island's beach is smaller than many surrounding resorts, both gulls and tourists take great joy in it. (Courtesy of Publisher: HPS.)

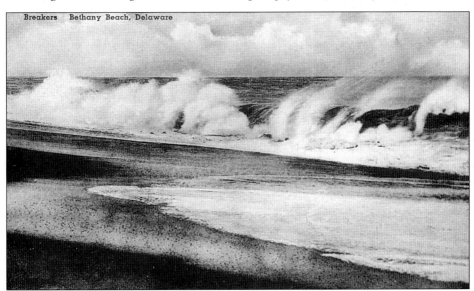

Breakers    Bethany Beach, Delaware

**FENWICK LIGHT**. Towering over the dividing line of Maryland and Delaware just north of Ocean City is the historic Fenwick Lighthouse which was built in 1859 to steer ships from shore and shoals, and can be seen from 15 miles out at sea. Its design is remarkable in that it is comprised of two brick towers instead of the usual one. Mr. and Mrs. Paul Pepper were the light keepers for years and recently the structure was renovated. (Courtesy of Alana Broadbent; publisher: HPS.)

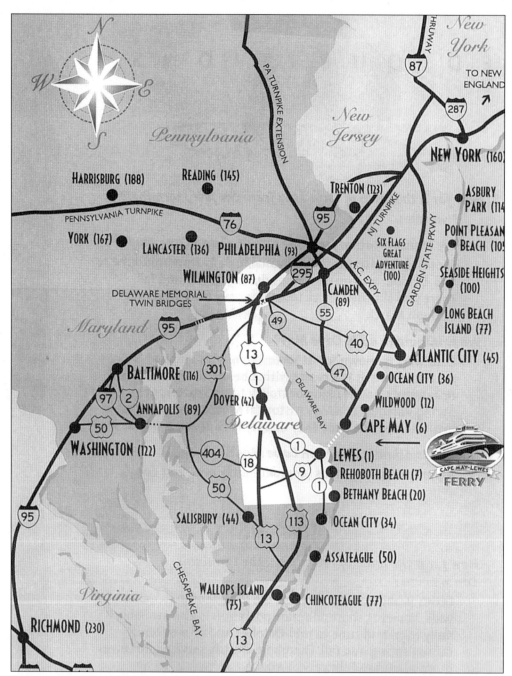

**BETHANY BEACH MAP.** Strategically located north of the demarcation line of Ocean City and Fenwick Island, Bethany Beach is a good choice for those who want something a little more exciting than the sedate Fenwick Island but a little less busy and crowded than the rapidly growing Rehoboth. The town is only 20 miles from the Lewes-Cape May ferry, and has entertainment, accommodations, and religious affiliations for nearly everyone's taste.

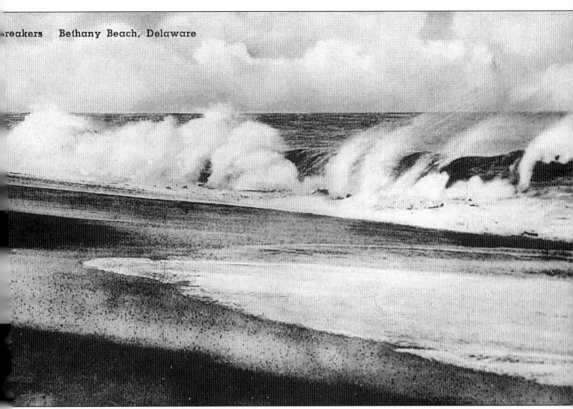

reakers    Bethany Beach, Delaware

**BETHANY BREAKERS.** Dated June 22, 1951, this card is addressed to a Mrs. Ball in Charleston, and reads "Having our two weeks vacation here . . . a wonderful change from D.C. heat." (Courtesy of John E. Jacob; publisher: H.A. Frazer.)

43

BREAKERS. This card, similar to the one on the previous page, is postmarked 1945 and was sent by a woman named Alberta. The card reads, "Have had only one good dip in the ocean. Been a bit cool and windy. . . Been crabbing and clamming but only caught a few." (Courtesy of John E. Jacob.)

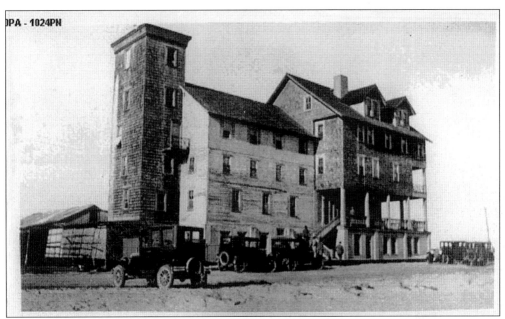

**SEASIDE INN, BETHANY BEACH**. This is an early 1900s photo of the Seaside Inn, which has always been a popular place to stay in Bethany. (Courtesy of Delaware Public Archives.)

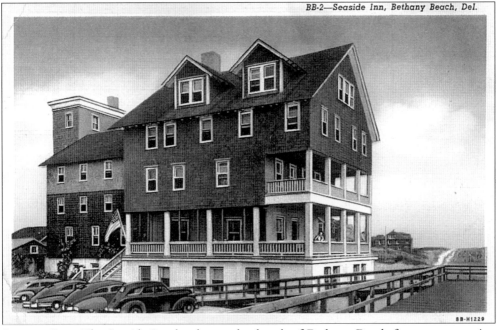

BB-2—Seaside Inn, Bethany Beach, Del.

8B-H1229

**SEASIDE INN**. The Seaside Inn has been a landmark of Bethany Beach for years, attracting many visitors, including the one who wrote on this *c.* 1940 postcard, "This is it! The ocean is right in front. Good food and clean . . . no keys for room doors, meals on the dot at 8, 12 & 6. Lots of families and children." (Courtesy of John E. Jacob; publisher: Harry P. Cann & Bro.)

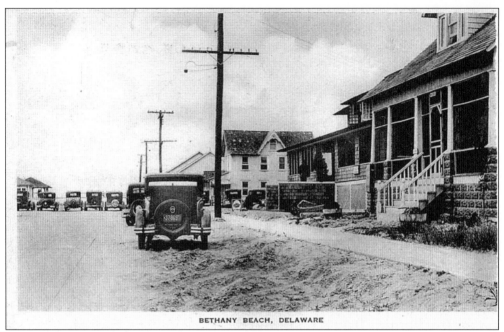

BETHANY BEACH, DELAWARE

**OLD-TIME BETHANY**. This 1940s postcard depicts Bethany Beach in her early years. The sender writes: "[Trying] to keep the rose arbor from going to waste next year. The scene is just right—moonlight on the ocean, grand beach." (Courtesy of John E. Jacob; publisher: Quality/Albertype.)

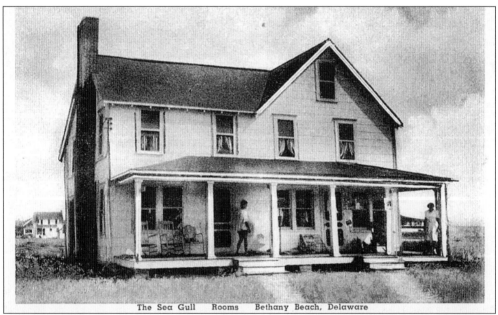

The Sea Gull    Rooms    Bethany Beach, Delaware

**THE SEA GULL.** Situated in an unpopulated area with only one or two other structures around it, the Sea Gull was similar to the warm and welcoming bed-and-breakfast inns we are familiar with today, with a cozy interior and shared meals and living quarters. (Courtesy of John E. Jacob; publisher: H.A. Frazer.)

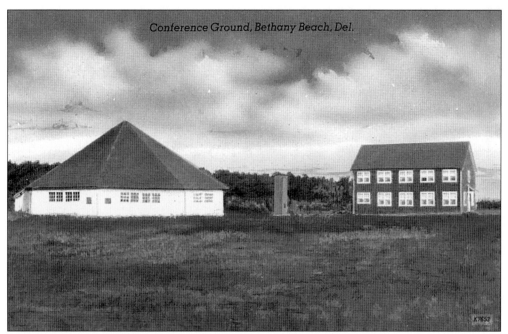

**CONFERENCE GROUNDS.** Postmarked 1957 and addressed to a Dr. Johnson at Augustine Cut-Off in Wilmington, this card reads, "Bet you would love it here; next cottage has a beautiful garden; the weather is ideal and oh so peaceful!" (Courtesy of John Jacob; publisher: Rodgers Record and Photo Shop.)

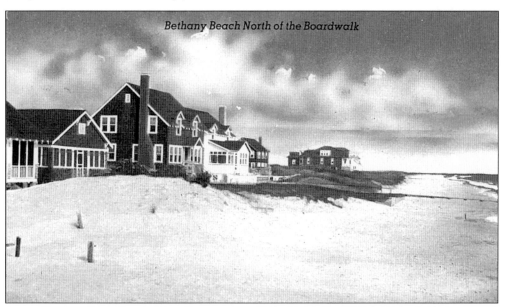

**NORTH OF THE BOARDWALK.** Here we can see what Bethany must have looked like around the time of this *c.* 1957 postcard when the cottages ranged in size, the sand came right up to the front door, and buildings had no zoning regulations. A man named Alfred writes to a party in Baltimore, "Have been enjoying the ocean . . . did go the wrong way for awhile [trying to get to the beach]." (Courtesy of John E. Jacob; publisher: Rodgers Record & Photo Shop.)

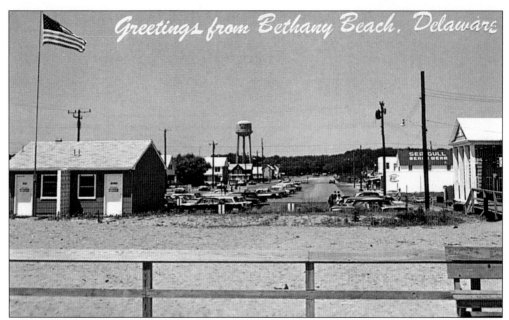

**SEAGULL BEACHWEAR.** Today's Bethany Beach isn't much different than what you see in this photo. Shot from the boardwalk, this image shows a business in the foreground and Seagull Beachwear in the background. The water tower bears the town's name as it overlooks a street leading to the beach (Courtesy of John E. Jacob; publisher: Tingle Co.)

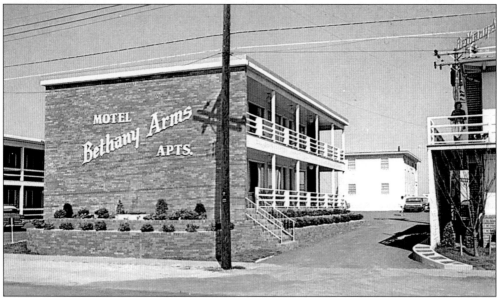

**BETHANY ARMS.** This oceanfront building contains apartments and motel rooms on both sides of the street and is located on Atlantic and Hollywood Streets. One of its early postcards advertised that it had heated rooms, was open all year, and was owned by Mr. and Mrs. Irvin B. Powell. Still open for business at its original beachfront location, Bethany Arms has gone through some changes over the years and is now a massive, modern complex. (Courtesy of John E. Jacob; publisher: Chuck West; Dexter Press.)

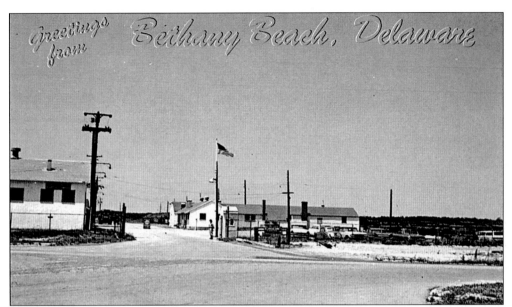

**SUMMER TRAINING CAMP.** This summer training camp was used for Delaware's National Guard; note the flag waving on the pole. A guard stands at the gate, and behind the building where he stands guard are army trucks and other vehicles. (Courtesy of John E. Jacob; publisher: Chuck West; Dexter Press.)

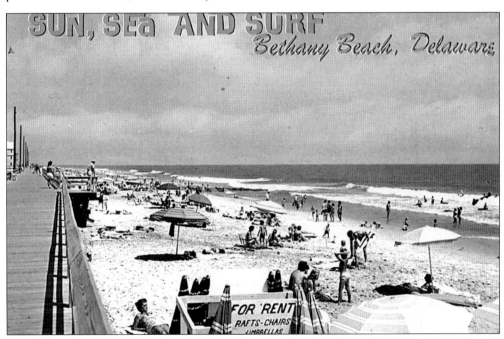

**FOR RENT.** This postcard, which shows the length of the beach and boardwalk, is probably a more recent card by the looks of the swimwear in the photo. The sign in the foreground reads "For Rent: Rafts, Chairs, Umbrellas." The back of the card reads, "Bethany Beach, one of the fastest growing summer playgrounds on the Atlantic Ocean." (Courtesy of John E. Jacob; publisher: Chuck West; Dexter Press.)

19

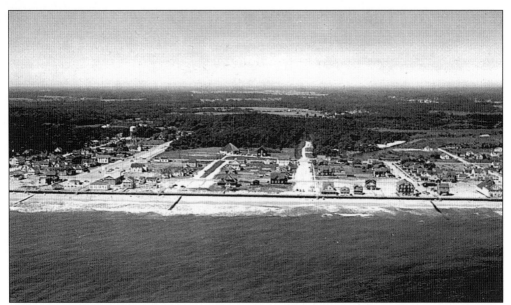

**AERIAL BETHANY.** This image gives an indication of how undeveloped this town is compared to many other seaside areas. The unpopulated land behind the shore resort is filled with tall trees. (Courtesy of John E. Jacob; publisher: Tingle Co.)

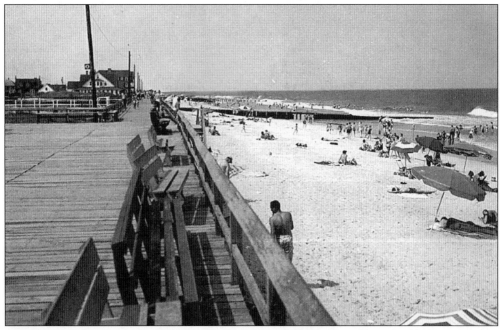

**BOARDWALK.** Postmarked 1964, this photo highlights the beach and boardwalk. By eyeing the people on the beach against the height of the wood, readers can get an idea of how high the boardwalk is. This beach area is small compared to the ones that have, even recently, pumped sand from the ocean onto the beach to keep it from eroding (thus losing tourists). In the middle of the card is a pier jetting out into the sea. (Courtesy of John E. Jacob; publisher: Carlin & Kremer/Tichnor.)

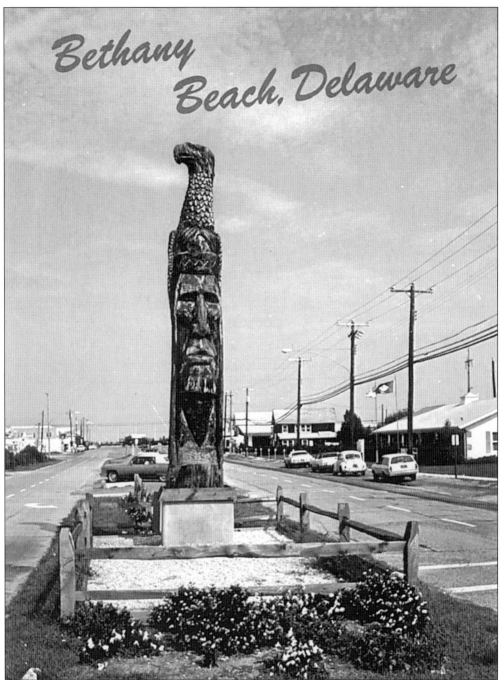

**TOAST OF THE TOTEM.** Titled for the Nanticoke chief, "Chief Little Owl," this 26-foot totem pole was carved, sculpted, and mounted in the spring of 1994, replacing the original carving of December 22, 1976, that was damaged by storms and termites. It towers in memorial to Delaware's Native Americans, and was hand-carved from a log by Peter Toth, who did several such poles for various beach areas along the Atlantic coast. (Courtesy of John E. Jacob; publisher: HPS.)

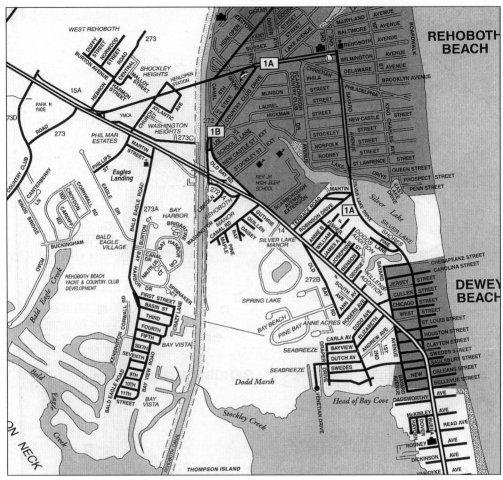

**DEWEY BEACH MAP.** Sitting snugly next to Rehoboth Beach is Dewey, a small resort town that boasts a yacht basin, white sandy beaches, and the Delaware Seashore State Park. Although the state park is non-commercialized, it does offer four-wheel vehicle access, a natural beach for sunbathing, beach strolling, treasure hunting, and activities like fly and surf fishing, clamming, crabbing, and swimming. Several World War II observation towers line the shore and Gordon's Pond is the home of soaring osprey, piping plovers, and many other types of wildlife. Numerous shops, a variety of lodging, and endless activities are also hallmarks of this quiet resort. (Courtesy of Rehoboth Beach-Dewey Beach Chamber of Commerce.)

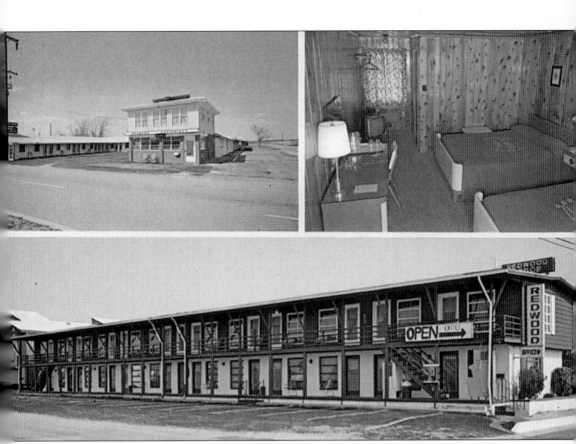

**REDWOOD AND SOUTHWINDS MOTELS.** These two motels accommodate many tourists who come for boating, swimming, and fishing. The Southwinds Motel went through extensive renovation and re-opened in 2001 under new ownership. The motel is conveniently located near a wide variety of restaurants and other entertainment options. (Courtesy of John E. Jacob; publisher: NaVar.)

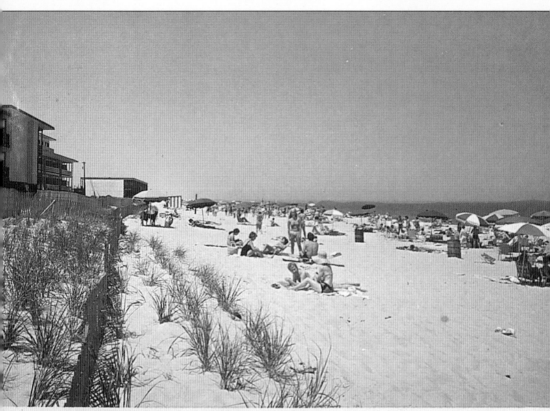

*Dewey Beach, Delaware*  Photo by R.C

**BEACHING AND SUNNING.** This picture, taken at Reed Street *c.* 1980, shows where dune grass was planted to keep the sand from eroding and how the motels were sitting right on top of the sand, unlike today's resorts that have gone to great lengths to replenish and widen their shorelines. (Courtesy of John E. Jacob; publisher: R.C. Pulling.)

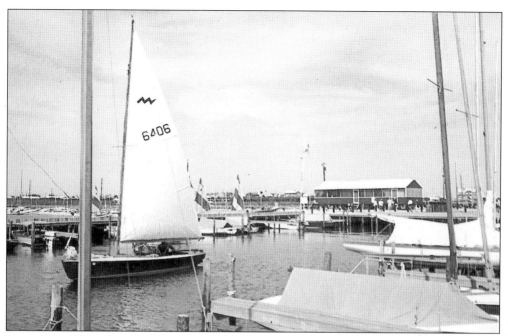

**FULL SAIL.** This photo is of boats in full sail keeping company with other expensive sailing vessels. (Courtesy of John E. Jacob; publisher: F.W. Breuckmann/Tingle Co.)

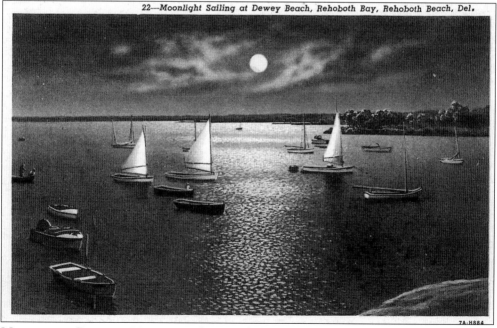

22—Moonlight Sailing at Dewey Beach, Rehoboth Bay, Rehoboth Beach, Del.

**MOONLIGHT SETTING.** Here we see boats in full sail out for a nighttime cruise. The majesty of a sailboat clipping down the water is an arresting view. (Courtesy of John E. Jacob; publisher: Harry P. Cann & Bro.)

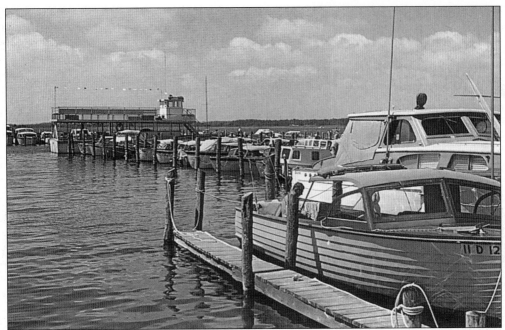

**DEWEY MARINA.** This is one of the many marinas gracing the shorelines of Delaware. These family cruisers and yachts are owned by resort residents and visitors. Often, private boaters will stay onboard their yachts while anchored at a resort. (Courtesy of Alan Broadbent; publisher: Tingle Co.)

**PIER THREE.** A fairly large body of water, Rehoboth Bay winds its way around several resort areas, including Dewey Beach. This pier sits on the bay beckoning to crabbers, clammers, boaters, skiers, anglers, and sightseers. In the background are lodging facilities and boat slips for the seafaring. (Courtesy of Alan Broadbent; publisher: Tingle Co.)

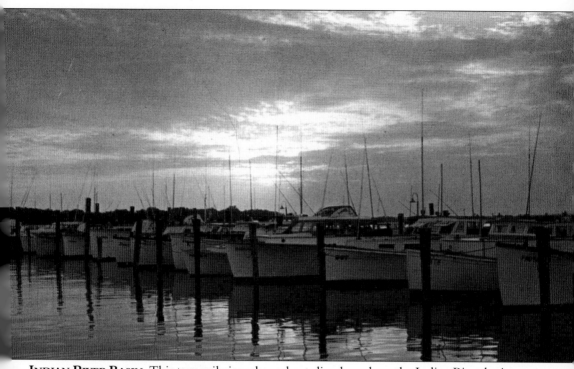

**INDIAN RIVER BASIN.** This tranquil view shows boats lined up along the Indian River basin at sunset. (Courtesy of Alan Broadbent.)

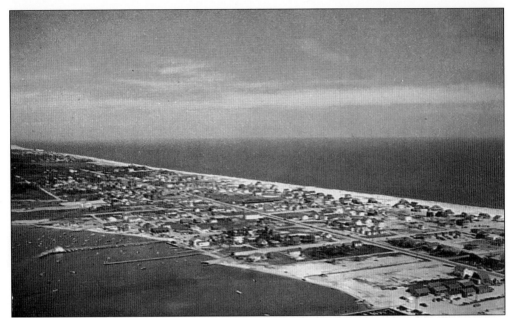

**AERIAL DEWEY.** An aerial of Dewey Beach gives an indication of how difficult sky shots used to be. Early aerial photographers not only had to be accurate in aiming, timing and technique, but also had to be capable of holding the camera steady when the plane hit air pockets. Today, mounted computerized cameras with high-tech locators and other mechanisms make the job a little easier. (Courtesy of Alan Broadbent; publisher: ColourPicture.)

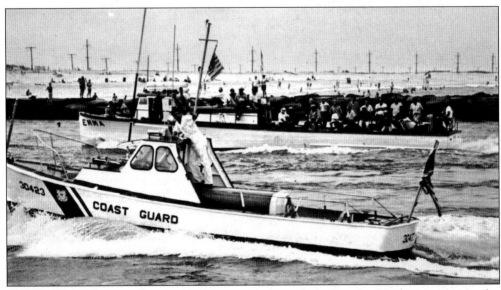

**INDIAN RIVER BASIN.** The Coast Guard and the Life Saving Station have maintained a presence in and around the coastal areas and have become especially important with increased population over the last 100 years or so. In the photo we see a cruiser skimming the Indian River waterway with onlookers on another boat in the background and on the sand. The stripe found on the U.S. Rescue ships is due to an edict by former President John Kennedy who believed the vessels should stand out from other boats. (Courtesy of Alan Broadbent.)

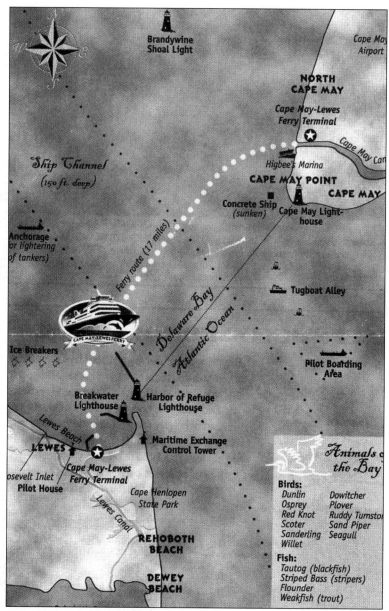

**MAP OF LEWES.** This image is of Lewes, a little resort jutting out of the peninsula to smile at its counterpart, Cape May, in New Jersey. Several ferries make their 70-minute trek across the Delaware Bay-Atlantic Ocean carrying hundreds of vehicles and many foot passengers. The ships are always packed with eager occupants who want to go to the Cape May area for fun, games, and something different than busy Atlantic City, while those from the Cape May end seek the Delaware beaches for their tranquility and endless boutique and outlet shopping. Many bus trips are offered on the Delmarva side for those who love the special deals allowing them to eat and hit the casinos. The ferry terminal on the Lewes end is very large and has many restaurants, gift shops, and a balcony to enjoy while taking in the fresh sea air. It is not uncommon to see hordes of jellyfish floating topside when you look down at the water from the ship's railing.

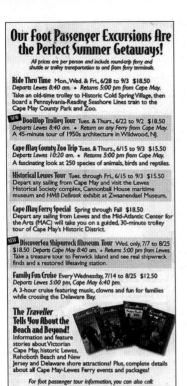

## Our Foot Passenger Excursions Are the Perfect Summer Getaways!

*All prices are per person and include round-trip ferry and shuttle or trolley transportation to and from ferry terminals.*

**Ride Thru Time** Mon., Wed. & Fri., 6/28 to 9/3  $18.50
*Departs Lewes 8:40 am. ♦ Returns 5:00 pm from Cape May.*
Take an old-time trolley to Historic Cold Spring Village, then board a Pennsylvania-Reading Seashore Lines train to the Cape May County Park and Zoo.

**NEW DooWop Trolley Tour** Tues. & Thurs., 6/22 to 9/2  $18.50
*Departs Lewes 8:40 am. ♦ Return on any Ferry from Cape May.*
A 45-minute tour of 1950s architecture in Wildwood, NJ.

**Cape May County Zoo Trip** Tues. & Thurs., 6/15 to 9/3  $18.50
*Departs Lewes 10:20 am. ♦ Returns 5:00 pm from Cape May.*
A fascinating look at 250 species of animals, birds and reptiles.

**Historical Lewes Tour** Tues. through Fri., 6/15 to 9/3  $15.50
Depart any sailing from Cape May and visit the Lewes Historical Society complex, Cannonball House maritime museum and *HMB DeBraak* exhibit at Zwaanendael Museum.

**Cape May Ferry Special**  Spring through Fall  $18.50
Depart any sailing from Lewes and the Mid-Atlantic Center for the Arts (MAC) will take you on a guided, 30-minute trolley tour of Cape May's Historic District.

**NEW DiscoverSea Shipwreck Museum Tour**  Wed. only, 7/7 to 8/25
$18.50  *Departs Cape May 8:40 am. ♦ Returns 5:00 pm from Lewes.*
Take a treasure tour to Fenwick Island and see real shipwreck finds and a restored lifesaving station.

**Family Fun Cruise** Every Wednesday, 7/14 to 8/25  $12.50
*Departs Lewes 5:00 pm, Cape May 6:40 pm.*
A 3-hour cruise featuring music, clowns and fun for families while crossing the Delaware Bay.

**The *Traveller* Tells You About the Beach and Beyond!**
Information and feature stories about Victorian Cape May, historic Lewes, Rehoboth Beach and New Jersey and Delaware shore attractions! Plus, complete details about all Cape May-Lewes Ferry events and packages!

*For foot passenger tour information, you can also call:*

**PERFECT SUMMER GETAWAYS.** A pamphlet available through Lewes Terminal lists several activities offered on the round-trip Cape May-Lewes ferry connections. These include old-time trolley rides through historic Lewes and Cold Spring Village, zoos, county parks, architectural tours, family cruises, and the Shipwreck Museum. (Courtesy of Cape May-Lewes Schedule Pamphlet.)

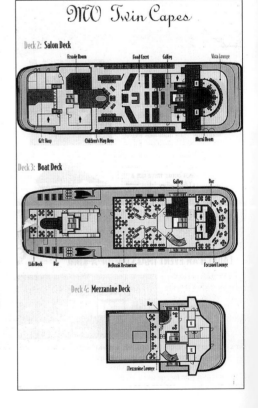

**TWIN CAPES.** This is the layout of the *Twin Capes*, with its three main decks—the Salon Deck, Boat Deck, and Mezzanine Deck. It carries 100 vehicles and 800 passengers. The Salon Deck contains a gift shop, arcade, play area, galley and lounge; the Boat Deck contains restaurants and bars; and the Mezzanine Deck is a bar and lounge. The ferry connection between historic Lewes and Victorian Cape May was launched in 1964. (Courtesy of Cape May-Lewes Schedule Pamphlet.)

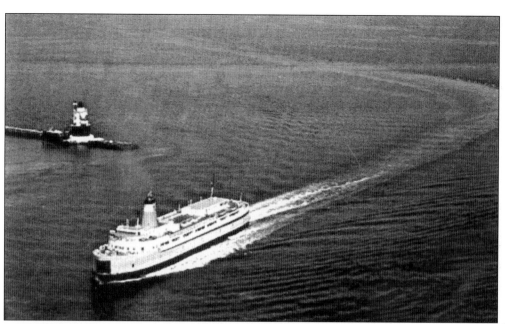

**FERRY BOATS**. The picture below is of the *Cape Henlopen*, which is larger than the *Twin Peaks*. The ferries serve a direct southward route from New Jersey and surrounding areas to all the wonders of the Delmarva Peninsula. (Top photo Courtesy of Alan Broadbent; bottom photo Courtesy of Cape May-Lewes Schedule Pamphlet.)

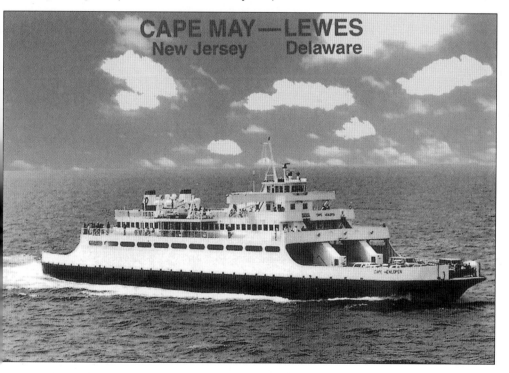

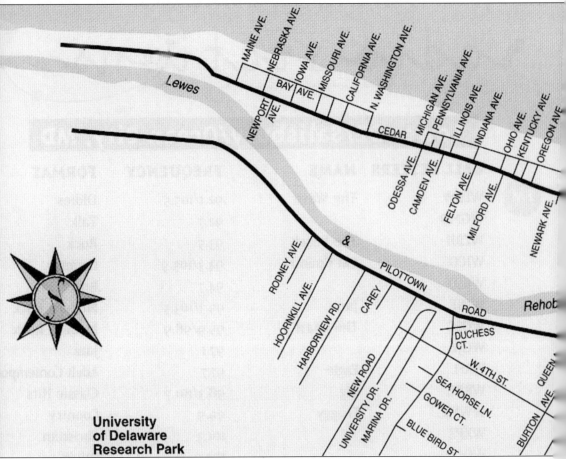

**LITTLE LEWES.** This map is of Lewes and indicates how small this little beach town actually is. Established as a fishing town, it was originally named "The First Town in the First State." It boasts a rich history, unique places to stay, eat, and shop, a charming downtown, numerous recreational activities, old churches, and a bevy of historical spots like the Old Firehouse, Governor Rodney House, Rabbit's Ferry House, Plank House, 1812 Memorial Park, and the United States Lifesaving Station. Lewes was discovered by Henry Hudson in August 1609, and soon after the Dutch decided that it was the perfect place to build a whaling station. Their existence was short-lived because the Lenni Lenape Indians, in a dispute over a Dutch coat of arms, slaughtered 32 settlers. Captain Kidd and other pirates also killed many residents and the War of 1812 took its toll as well. One of Lewes's buildings has a cannonball embedded in its structure. Another notable feature is the 4,000-acre Cape Henlopen State Park. Lewes is proud to host many events, a variety of entertainment options, and endless land and water activities. (Courtesy of Cape May-Lewes Schedule Pamphlet.)

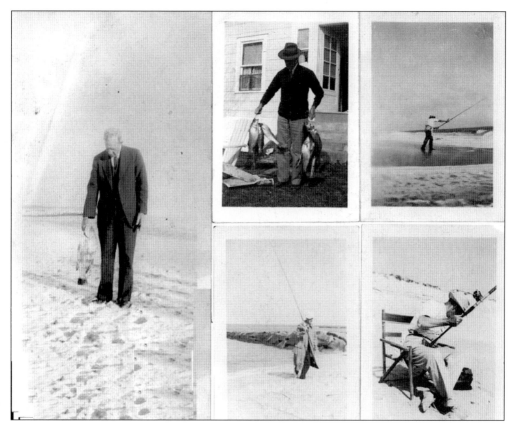

**FISHING, 1930s–1940s.** In the image at far left, Alan Broadbent's grandfather, Mr. Ammon, is standing on the beach of the Indian River inlet in a three-piece suit and dress shoes dangling a fish. He was famous in the Rehoboth-Dewey area for his angling skills and for having invented a special style of bait. In the top middle image he stands in his backyard at 10 Laurel Street (which no longer exists) before moving to 120 Norfolk Street in a house that remains today. Note in this image the old wooden outdoor furniture. The remainder of the photos show him in various fishing poses. (Courtesy of Alan Broadbent.)

**ON SAND, ON SWING IN SUIT.** It seems Alan's grandfather enjoyed dressing counter to what one would expect. In these two pictures, we see Mr. Ammon in his usual semi-formal attire of a suit, bowtie, and hat on the beach. Notice, too, how fashionable the women are dressed for the time. Alan identifies the location of the photos as Lewes Beach. (Courtesy of Alan Broadbent.)

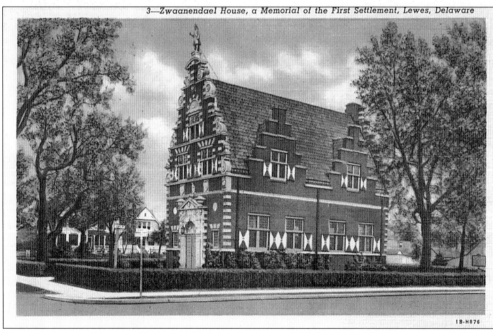

**ZWAANENDALE HOUSE.** Built in 1931 by the state of Delaware, this museum and library (named after the original settlement in Delaware) commemorates the massacre of the 1631 Dutch settlers. It is a replica of the Town Hall (Staidhuis) in Horn, Holland. This attraction is on Savannah Road and Kings Highway and is open seven days a week. There is no admission charge but donations are welcome. (Courtesy of publisher: Harry P. Cann & Bro.)

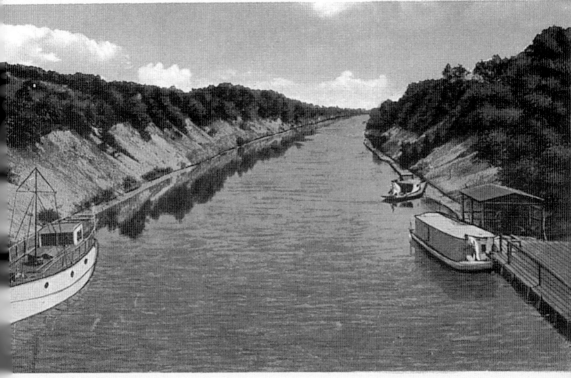

**REHOBOTH CANAL.** Besides serving as a passageway and a link, this canal provides opportunities for pleasure boating and other water activities. (Courtesy of publisher: Louis Kaufmann and Sons.)

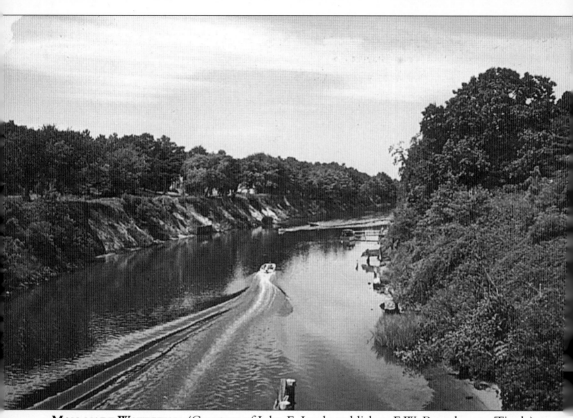

**MAN-MADE WATERWAY.** (Courtesy of John E. Jacob; publisher; F.W. Breuckmann/Tingle)

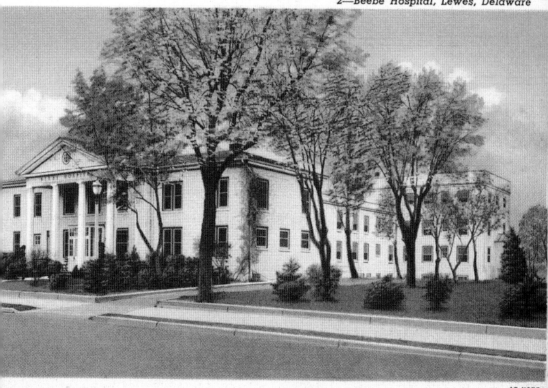

**BEEBE HOSPITAL.** The Beebe medical center has grown by leaps and bounds in its 85-year history. Public relations officer Sherry Perry explains, "We're a 148-licensed-bed hospital with cardiac, cancer, and vascular centers, along with an orthopedic department that's known for performing joint replacements. We also have an excellent women's health pavilion and birthing center and an outstanding Level III trauma center." Over 150 physicians are affiliated with the hospital which becomes bigger, better, and more high-tech with each passing year. (Courtesy of Alan Broadbent; publisher: Harry P. Cann & Bro.)

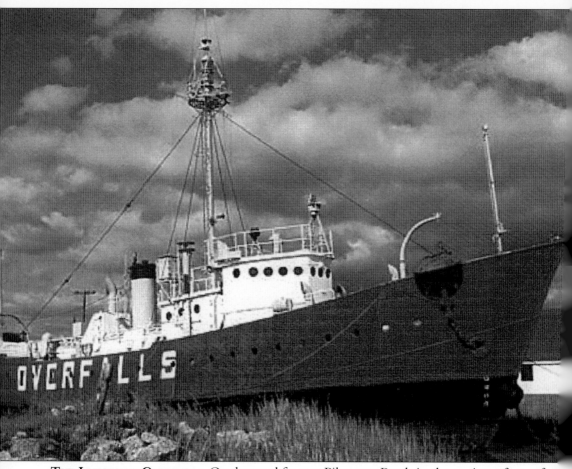

**THE LIGHTSHIP *OVERFALLS*.** On the canal front at Pilottown Road sits the vestiges of one of the last lighthouse boats, which was bestowed upon the Lewes Historical Society by the United States Coast Guard in 1973. When it was moved from Boston to Lewes, it was re-christened the *Overfalls* after its ancestor lightship which patrolled the Delaware Bay from 1892 to 1961. The *Overfalls* Lightship Association looks after the once sea-worthy relic. This is a fitting end for this chapter and its town of Lewes, the oldest original settlement. (Courtesy of Gary Stabley.)

# *Two*

# HISTORY

## ONCE UPON A TIME

*Hundreds of years ago, Rehoboth, like most of the shoreline, was uninhabited. Beaches were wide and buildings were non-existent. Visitors to the area were rare and were only those adventurous souls willing to face the gushing tides, roaring gales, and absence of life or food for miles. In 1873, a Methodist minister came to Rehoboth with a dream of founding a religious tent city near the water. Thus began the development of Rehoboth as we know it today. Attracted by the appeal of a calmer and more affordable lifestyle, beaming sun, and wide watery expanse for swimming, fishing, and sailing, city dwellers began filtering into the town and promptly turned the old-fashioned village into the nation's summer capital.*

*Soon, farmlands dwindled, the railroad went the way of parlor games, the poultry industry diminished, and large, grassy knolls turned into cement. A modern boardwalk replaced the serene walkway, cars beeped and putted along, school bells rang, shops began lining the boardwalk, and delightful, old-fashioned lodging facilities turned into modern hotels and motels. Today Rehoboth remains a popular resort—in some ways even more than commercialized Ocean City—because Rehoboth, much like its neighboring communities, has managed to retain its small-town charm and quaintness. Most of the industrial areas are outside the fan-shaped acres of Rehoboth, while the artistic and antiquated shops and concessions exist on Rehoboth Avenue and its side streets. The tents of the Methodist camp meetings blossomed into cottages that, in turn, were converted to homes. Some of these original tent-cottages exist today amongst the breathtaking pine and holly trees for which Rehoboth is known.*

*Strategically located between the lower resorts (Assateague Island, Ocean City, Fenwick Island, Bethany Beach, and Dewey Beach) and the upper shore attractions (Lewes, Cape Henlopen Park, the Cape May-Lewes Ferry, Slaughter Beach, and Bowers Beach), Rehoboth maintains its popularity and continues to attract ever-growing crowds who stumble upon one of the high points of the Atlantic Ocean. Here they can lie on the white sandy beaches, feel and smell the fresh sea air, hop a boat for a ride or fishing, hunt and golf, or just shop until they drop. This chapter will start your excursion through beautiful Rehoboth Beach and surrounding boroughs.*

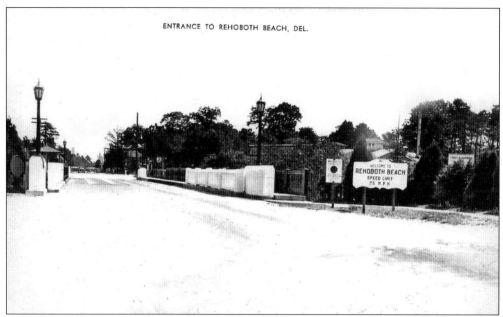

ENTRANCE TO REHOBOTH BEACH, DEL.

**ENTRANCE TO REHOBOTH, EARLY 1900S.** At the time of this postcard, Rehoboth was just becoming known as the "nation's summer capital." Tents would become homes, dirt lanes would berth railroad tracks and become paved roads, and a section of the beach would be partly covered by a wooden walkway called "the boardwalk." (Courtesy of John Jacob; Publisher: Mayrose Publishing Co.)

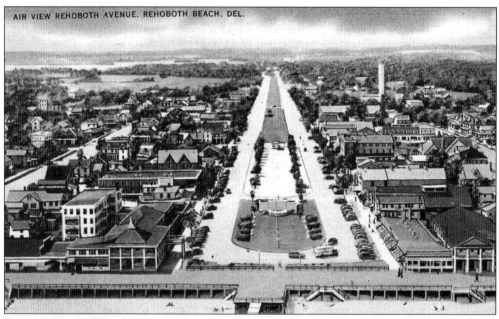

AIR VIEW REHOBOTH AVENUE, REHOBOTH BEACH, DEL.

**AERIAL VIEW, 1920S.** This *c.* 1920 postcard is of Rehoboth Avenue. The sender writes to a party in Camp Hill, Pennsylvania, "Am having a [good] time. The water is swell . . . It's very hot. Ian McCarter is down here. He works on the merry-go-round." (Courtesy of John Jacob; Publisher: Del Mar News Agency.)

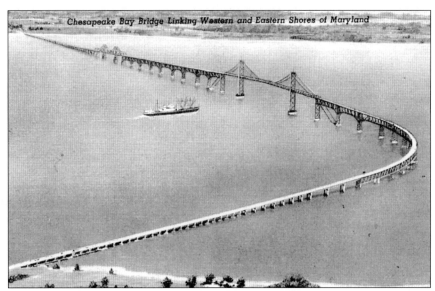

Chesapeake Bay Bridge Linking Western and Eastern Shores of Maryland

**WATERWORLD.** Rehoboth is sandwiched between the Chesapeake Bay and the Atlantic Ocean, making for interesting and confusing weather. Its early history was a quiet one, until the building of bridges opened up a new world for the eastern shore. The top photo shows one of the modern wonders of the world—the Chesapeake Bay Bridge, which connects the western shore of Maryland to the eastern shore. The first lane was completed in 1954 at a cost of $45,000 and the second lane was erected shortly after. The third-longest bridge in the world, it has 123 spans, is 7 miles long, and over 4 miles above the water at its peak point. Westerners would take Route 50 across to 404 to Georgetown and then Route 9 to Rehoboth. Notice the line-up of the seaside resorts along the Delmarva Coast: south is Assateague and Chincoteague in Virginia, followed by Ocean City, and to the north are Fenwick Island, Bethany Beach, Rehoboth, and Dewey Beach. (Courtesy of Colortone.)

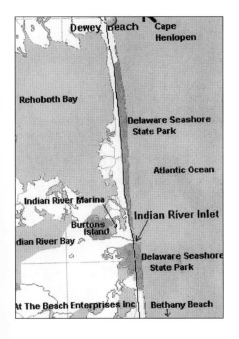

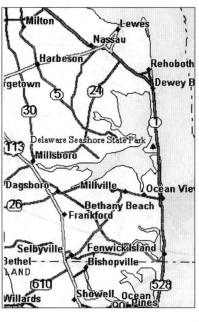

41

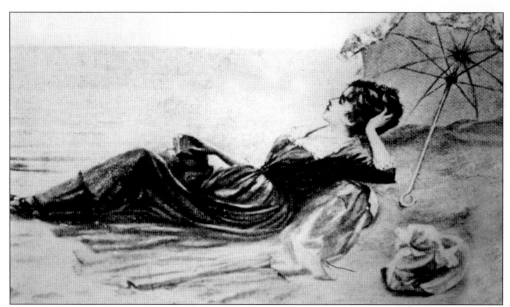

**UNDER THE UMBRELLA, EARLY 1900S.** In this image, titled "Lonesome," a woman of leisure reclines under a frilly umbrella. Sunbathing was a favorite recreational activity during the early years of the resorts, and initially only the well-to-do practiced such diversions from their usual urban lifestyles in Baltimore, D.C., Philadelphia, and Norfolk. (Courtesy of Anna Hazzard Museum of the Historical Society of Rehoboth Beach, Delaware.)

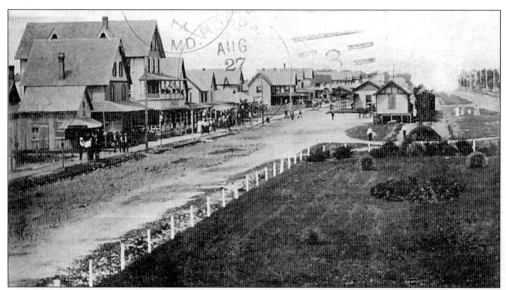

**REHOBOTH AVENUE SOUTHSIDE, 1907.** This image gives a sense of what Rehoboth looked like at the turn of the century. People and horse-drawn carriages mill about on dirt streets, which were also used as sidewalks. The card is addressed to a Mildred Nuttle of Hobbs, Maryland, with this note written on the bottom: "Tell sister that I will send her a card. My dear little girl and I have been wondering what I shall bring home to you." The oval on Rehoboth Avenue remains a major attraction. (Courtesy of John Jacob; publisher: Souvenir Post Card.)

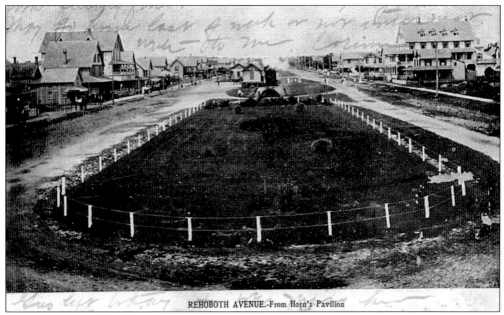

**HORN'S PAVILION, 1910.** In this view of Rehoboth Avenue, taken from Horn's Pavilion (a popular landmark), the oval is visible. The official name of the oval is "The Flower Garden." The tall building at the right is the Hotel Carlton. This card, requiring a 1¢ stamp, is also addressed to a Mrs. Nuttle, but in Denton, Maryland instead of Hobbs. (Courtesy of John E. Jacob; publisher: Souvenir Post Card.)

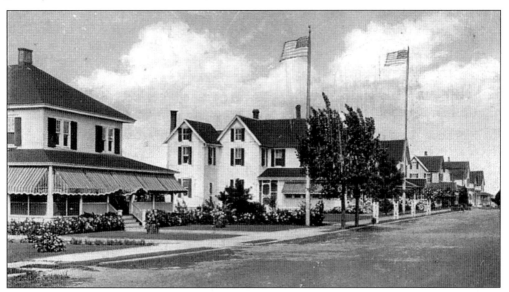

**OLIVE AVENUE, 1910.** If you were standing in the foreground of this photo on Olive Avenue, you would be facing the ocean. The buildings on this avenue are especially well kept, landscaping is meticulously manicured, and United States flags wave proudly. The back of this card has a line down the middle, which is indicative of the early 1900s, allowing people to write on one side and address the other side. (Courtesy of John E. Jacob; publisher: Louis Kaufmann & Sons.)

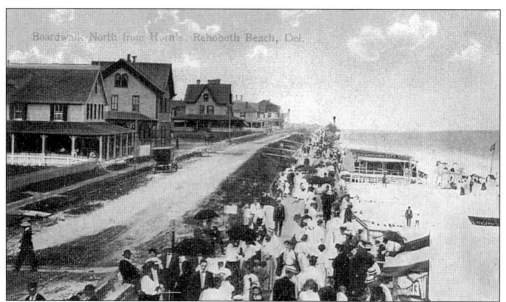

**OPEN AIR BOARDWALK, MID-1900S.** Unlike today, where concessions line the boardwalk, these "boards" extended far from the buildings. The first boardwalk was built in 1873, and 1903 saw the first concession stand. Notice how well dressed the tourists are in this picture and the characteristic white sand. (Courtesy of Alan Broadbent.)

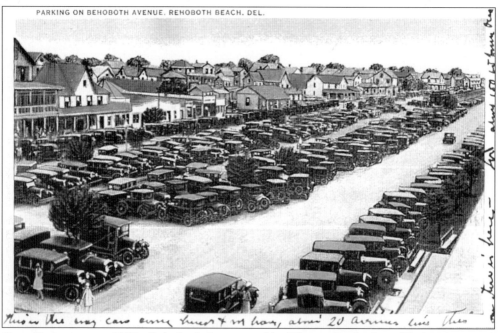

**CARS EVERYWHERE, 1920S.** Rehoboth Avenue and its "Flower Garden" are filled with antique cars. Rehoboth boasted its first public gas pump in 1918. Although this card was never mailed, the purchaser noted with an arrow on the right side that her auto was located about "150 feet from the oval." The location of the oval and the buildings on the left side look very much the same today. (Courtesy of John E. Jacob; publisher: Horns, Inc.)

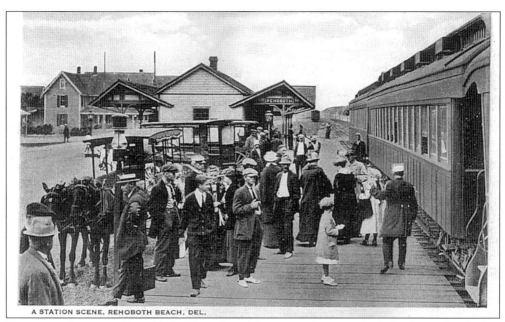

A STATION SCENE, REHOBOTH BEACH, DEL.

**RAILROAD STATION, PRE-1928.** The railroad from Harrington to Rehoboth was finished in 1878; a year later a station stood proudly in the middle of Rehoboth Avenue. Riders dressed in their Sunday best stand on the platform; horse-drawn carriages served as transportation to and from the station. Railroad service was discontinued in 1928. (Courtesy of Alan Broadbent.)

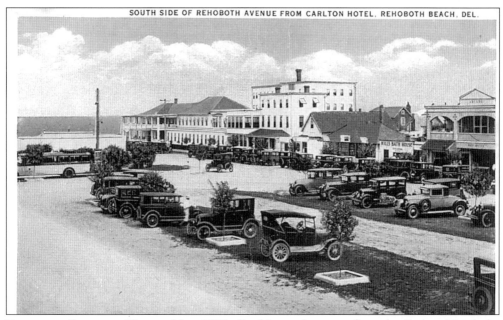

SOUTH SIDE OF REHOBOTH AVENUE FROM CARLTON HOTEL, REHOBOTH BEACH, DEL.

**FROM THE CARLTON HOTEL, MID-1920S.** Looking at the ocean from the Carlton Hotel, the oval on the south side of Rehoboth Avenue is visible, as are Hill's Bathhouse and the former post office, now an arcade. These buildings are large and colonial in style with lots of windows for a good view of the ocean and downtown Rehoboth. (Courtesy of Alan Broadbent; publisher: Louis Kaufmann & Sons.)

**BATHING BEAUTY, 1939.** Alan Broadbent's mother, Lois Ammon, poses in her bathing suit on a beautiful beach day. The rowboat she is on was probably privately owned and used for fishing or giving rides to the tourists. The back of the photo simply says, "Lois Ammon, Rehoboth, sweet 16" and the date is August 1, 1939. (Courtesy of Alan Broadbent.)

**GREETINGS, 1960s.** A souvenir folder of postcards featured a host of familiar Rehoboth images, including the boardwalk, the pines, and the beach. (Courtesy of Alan Broadbent; publisher: Rogers Record & Photo.)

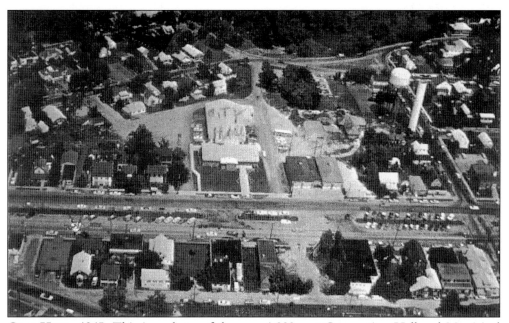

**CITY HALL, 1965.** This is a photo of the new 1,000-seat Convention Hall and Municipal Building with the fire company on the right. The owner of this postcard etched the words "City Hall" on the front of the card. (Courtesy of Alan Broadbent.)

GREETINGS FROM REHOBOTH BEACH DEL.

© CURT TEICH & CO., INC.  4B-H1130

**NEVER A DULL MOMENT, 1951.** The large letters of the town's name are filled with keystone markers of the resort, the beach, churches, lighthouse, lakes, pines, and umbrellas. The sender of this postcard is named Pep; he writes that there is never a dull moment and that Rehoboth Beach is "swell." (Courtesy of John E. Jacob; publisher: Art Colortone.)

**DELAWARE, 1940S AND 1950S.** The top postcard is addressed to a party in Virginia with a note stating, "After Tangier Island, glad to be back on the mainland . . . Hope this heat wave hasn't hit Richmond." Tangier Island is accessible only by boat and the residents tend to have a distinctive middle-English accent and keep mainly to themselves. (Courtesy of John E. Jacob and Alan Broadbent; publisher: Art Colortone).

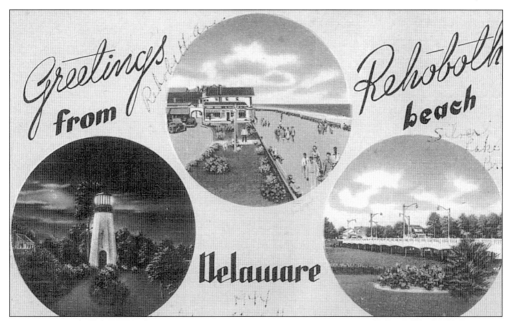

**A TRIPOD OF IMAGES.** At the bottom of this postcard, the date 1944 was written along with names of the featured points. In the circle at the left is Cape Henlopen Lighthouse, the middle circle is Rehoboth Avenue, and the circle at the right shows Silver Lake. (Courtesy of John E. Jacob; publisher: Edward Stores.)

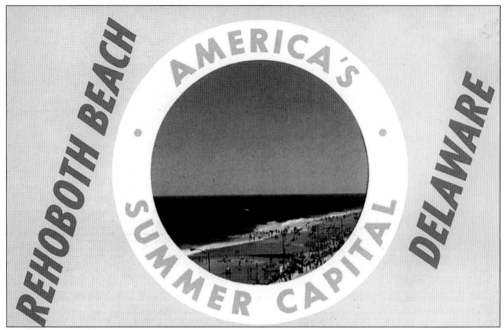

**SUMMER CAPITAL, 1960S.** The phrase "America's Summer Capital" is in large letters encircling the image of the beach. The back of this postcard says, "Time and Tide Wait For No Man But Beautiful Rehoboth Beach Is Waiting For You." (Courtesy of John E. Jacob; publisher: Tingle Co.)

**PICTURE POSTCARDS, 1970S.** Waves gush onto the wide beach in this card, which shows the town in the background to the left. (Courtesy of Alan Broadbent; publisher: Tingle Co.)

# *Three*
# BEACH AND BOARDWALK
## TANNING AND TREADING

*Why does anyone vacation at a seaside resort? For the beach and the boards, to put it simply. There is something special about treading the boardwalk, feeling the wood and sand under your bare feet, smelling the salty sea air and the tantalizing foods from the concession stands, riding bikes, tricycles, or even a train down the boardwalk, watching sunbathers soak up the rays, and hearing the tides roar and whisper.*

*Many sun lovers aren't ray worshippers at all; rather they are watchers of the opposite sex. The sand sees the best and most provocative bathing suits, hears both the superficial and deep conversations, and feels the weight of all humans. Many sunbathers come to see or be seen, while others prefer swimming. For whatever reason tourists visit coastal play lands, Rehoboth Beach and its boardwalk fills their needs. In fact, some of the nation's most celebrated figures have honored the resort with a visit. This includes former U.S. Presidents Richard Nixon, Dwight D. Eisenhower, and Harry Truman; former Vice President Al Gore; Chelsea Clinton; Sen. John G. Townsend; Eleanor Roosevelt; Judge Sirica; and various dukes and other royalty. Such notable guests patronized the early landmarks, including Horn's Pavilion, Hill's Bath House, Lingo's Market, Silver Lake, North Shores, Whiskey Beach, and Henlopen Acres. They have stayed in the Bright and Surf Hotels, the Henlopen Hotel, the Belmont, the Atlantic Hotel, and numerous others as well as cottages.*

*The mound between the beach and Surf Avenue anchored the first boardwalk in 1873, which was about 8 feet wide and 1,000 yards long—then the entire length of the beachfront. It was extended in 1884 and rebuilt after the 1914 storm; this is a chore in constant motion since storms take a liking to hitting and ripping up the wooden planks. Today, the boardwalk is about one mile long. Over the years, sand has shifted and eroded in some spots while piling up in others. As you flip through these pages, tread these boards with us and lie under the heat of the sun to get a feel for what it was like "back then."*

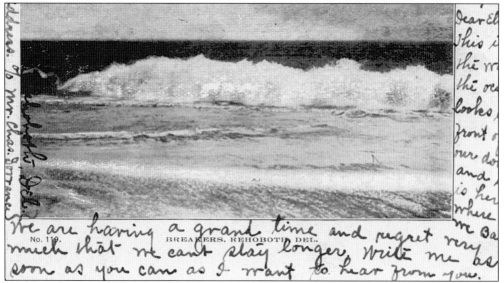

Handwritten text on postcard: *Address to Mr. Chas. Bottcher [...] Del.* / *Dear El[sie] This i[s] the w[ay] the oc[ean] looks, front o[f] our do[or] and [...] is her[e] where we ba[sk] [...]* / *We are having a grand time and regret very much that we can't stay longer. Write me as soon as you can as I want to hear from you.*

No. 119. BREAKERS, REHOBOTH, DEL.

**ROARING WAVES.** This postcard image is dated 1905 and was sent to Carroll County, Maryland from Rehoboth. The sender writes, "8/4/05. Dear Elsie: This is the way the ocean looks in front of our door and it is here where we bask. We are having a grand time and regret much that we can't stay longer. Write me as soon as you can as I want to hear from you. With lots of love to all, from your loving cousin, Laura." In the early 1900s the beach was much closer to the buildings because no replenishment projects had been developed. (Courtesy of John E. Jacob; publisher: Souvenir Postcard.)

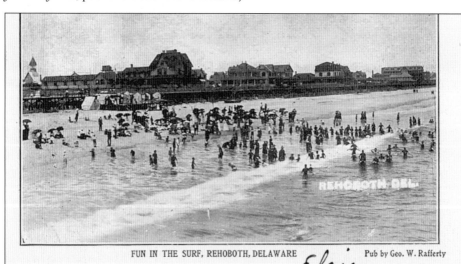

FUN IN THE SURF, REHOBOTH, DELAWARE          *Elsie*          Pub by Geo. W. Rafferty

**SURF AND SAND.** Mailed August 27, 1907, this card was sent to Halethorpe, Maryland at a time when swimming seemed to be more popular than sunbathing. Unlike today, female swimmers wore full bathing suits that were unattractive and bulky, but were still an improvement over the suits of the 1880s that consisted of about 10 yards of heavy material, skirt, and corset. Men's swimsuits went from full-body cover to topless with trunks, designed to be more fashionable. In this picture, Rehoboth landmarks and the boardwalk can be seen in the background. (Courtesy of John E. Jacob; publisher: Geo. W. Rafferty.)

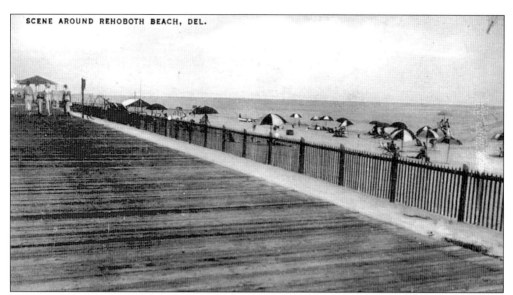

**THE BOARDWALK.** Dated *c.* 1918, this card highlights the boardwalk, which was initially constructed in 1873. Wide and smooth, the boards look very similar to the ones that exist today, though many storms have ripped up the lumber and tossed the wood into the sea over the years. The canopy in the background may have served as a platform for entertainment. (Courtesy of John E. Jacob; published: The Mayrose Co.)

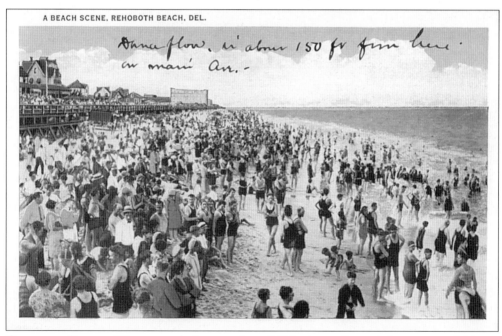

**CROWDED BEACH.** Women wade in one-piece, full-body outfits and the men model long, baggy trunks with string t-shirts covering their chests. Those standing back from the water's edge are dressed in street clothes. The postcard writer has jotted down: "Our floor is about 150-feet from here on main Avenue." Notice that the boardwalk is also crowded. (Courtesy of John E. Jacob; published by Horns, Inc.)

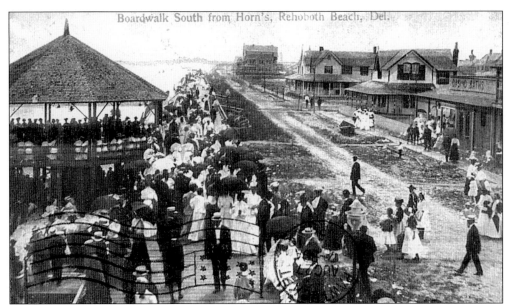

**BOARDWALK SOUTH, 1910.** A view from famous Horn's Pavilion shows the bathhouse to the right off the dirt road. Victorian lampposts line the street and the oval shows an abandoned rowboat. Sent for a penny to Michael Creed in Pawtucket, Rhode Island, the card reads, "Hello, Papa! Having a nice time down here. Hope you are all right," and is signed "Sadie." (Courtesy of Alan Broadbent; publisher: Horn's.)

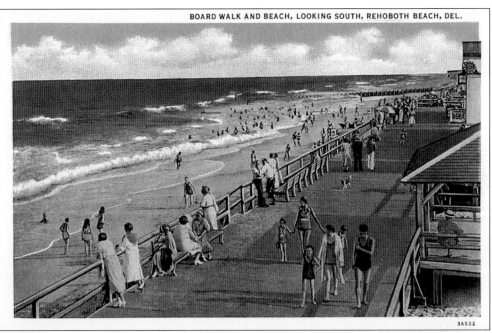

**LOOKING SOUTH, 1915.** Unlike the image above, this one was taken on a bright, sunny day with tourists wearing pastel colors, and men walking the boards and swimming in string bathing suits. Note the women in the foreground leaning against the railing and looking out to sea. (Courtesy of John E. Jacob; publisher: Louis Kaufmann & Sons.)

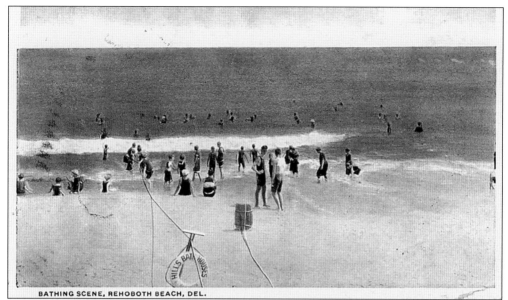

BATHING SCENE, REHOBOTH BEACH, DEL.

**BATHING SCENE, 1920.** Bathers play in the water near the buoy line on an unusual not-so-crowded day at the beach. Back then, such lines were strung into and anchored in the water—with the help of a keg in the sand—so that bathers wouldn't go underground from sudden rip tides. The sender, Helen, writes to Nettie in Baltimore, "Having a fine time, sorry your girls are not able to join us, weather great, how is it in Balto." It is postmarked June 29 at 3 p.m. (Courtesy of John E. Jacob; publisher: Louis Kaufmann & Sons.)

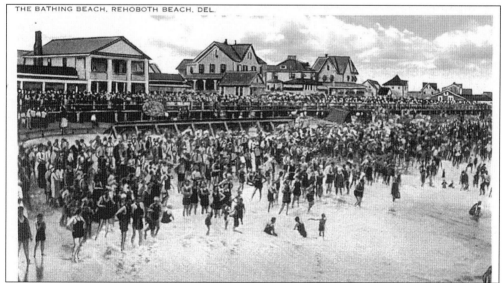

THE BATHING BEACH, REHOBOTH BEACH, DEL.

**PEOPLE ALL OVER, 1920s.** In this photo, we see the landmark buildings of Rehoboth and a crowd of people covering every grain of sand. Prior to World War II, bathers spent more time on the beach and boardwalk than they did in the water. Swimming suits of the time were designed for sun protection, not fashion. After their morning swim, tourists would return to their hotels to change for a boardwalk stroll or to attend a live band concert in the afternoon. (Courtesy of John E. Jacob; publisher: Louis Kaufmann & Sons.)

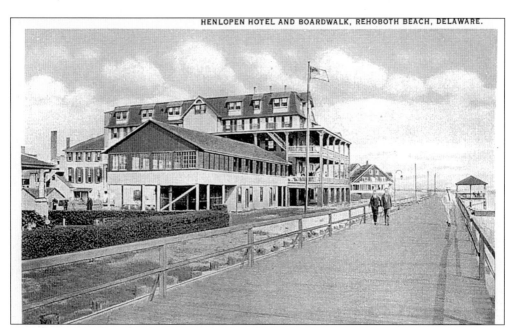

**HENLOPEN, 1920s.** No chapter on the boardwalk could go written without featuring the world-famous Henlopen Hotel. The three men moseying along in front of the hotel are dressed in three-piece suits with ties and hats. Rehoboth is usually hot in the summer, even on its coolest days, so this is probably an early morning stroll. (Courtesy of Alan Broadbent.)

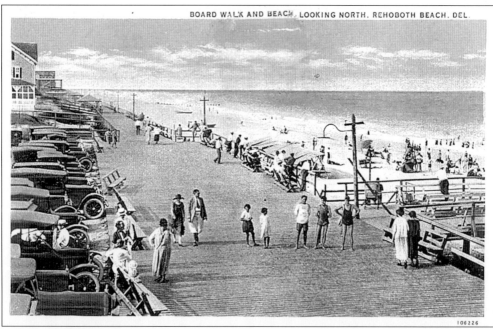

BOARD WALK AND BEACH, LOOKING NORTH, REHOBOTH BEACH, DEL.

**A UNIQUE VIEW, 1920s.** This photo offers a glimpse of the pier jutting off the walkway out into the sand. Notice the pavilion in the distance, the man in the foreground wearing a tie with a gray coat and white baggy shorts almost reaching to his ankles, and the railing leading to the hotel entrances. (Courtesy of Alan Broadbent.)

REHOBOTH AVENUE PARK, REHOBOTH BEACH, DEL.

**LONELY BENCH, 1951.** For such a popular resort, it is unusual to see an empty bench and desolate landscape in this postcard. In addition to the buildings, which exist today, a trellis sits to the right of the bench. (Courtesy of John E. Jacob; publisher: The Mayrose Co.)

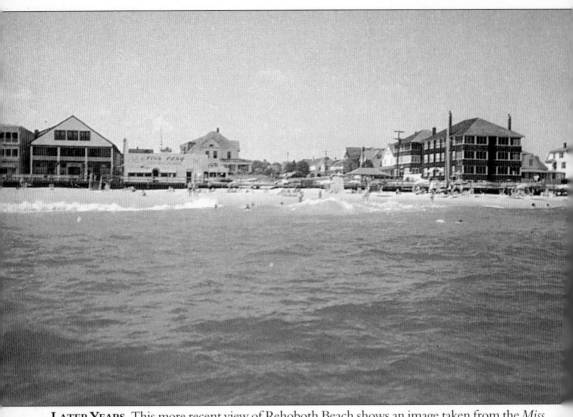

**LATER YEARS.** This more recent view of Rehoboth Beach shows an image taken from the *Miss Nottingham.* Wagner's Candy Gift and Novelty Shop is in the forefront. The structure with the pastel trim is Jimmy Booth's "The Pink Pony" Night Club—once an exclusive spot. The next building is Polly Harris's Kent and Sussex Apartments. (Courtesy of John Jacob; publisher: Rodgers Record & Photo Shop/ Ruth.)

72769

**WAVING AMERICAN FLAG, 1953.** Postmarked July 17, 1953 at 5 a.m., this card was sent to a party in Wilmington from a woman named Esther, who writes, "Hi, having swell time. Weather is grand. Getting nice tan. See you next week." Note the detail in this card—people standing under store canopies on the sidewalk, cars motoring down the street in the background, and the flowers in the foreground. (Courtesy of John E. Jacob; publisher: Tichnor Bros.)

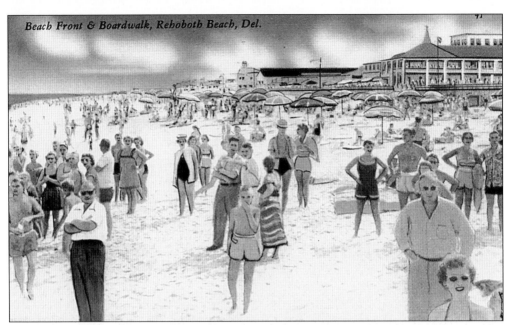

Beach Front & Boardwalk, Rehoboth Beach, Del.

**BEACHFRONT AND BOARDWALK, 1955.** This postcard almost looks like a painting. It was mailed to Camp Hill, Pennsylvania, from a girl named Joanne, who writes, "Dear Mom, Dad, Bob, the bologna really came in handy, we all love it. We had it fried. We went on a two-hour boat trip." We can tell this card is not from the 1920s, 1930s, or 1940s because the beachcombers are dressed in pastel colors—not black—but the style of the bathing suits indicate that it is not a modern image either. (Courtesy of John E. Jacob; publisher: $1 Store.)

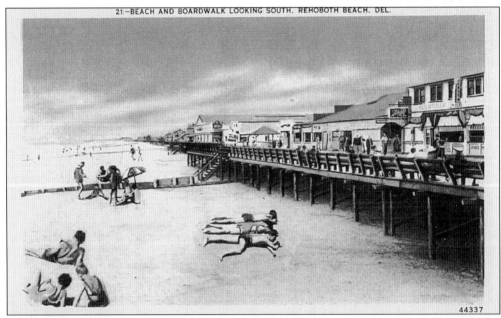

21:—BEACH AND BOARDWALK LOOKING SOUTH, REHOBOTH BEACH, DEL.

44337

**CATCHING THE RAYS, 1950s.** The stairway comes off the boardwalk and runs across the sand for those who prefer warm wood to hot sand. It wouldn't take much for someone to tumble over a bench to the beach below! (Courtesy of John E. Jacob; publisher: Harry Cann & Bro.)

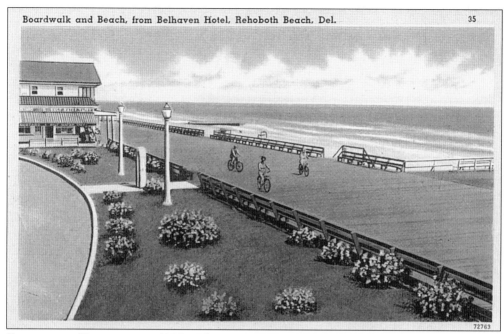

**RIDING THE BOARDWALK, 1950s.** This image was taken from the Belhaven Hotel. Riding bikes on the boardwalk is a favorite activity of many vacationers. (Courtesy of John E. Jacob; publisher: Edward Stores.)

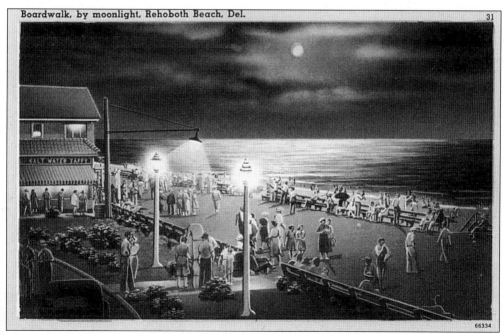

**MOONLIGHT MERRY, c. 1956.** Here we see a clogged boardwalk and busy street with tourists in their finery, which seems brighter under the Victorian lamps and luminous moonlight. (Courtesy of John E. Jacob; publisher: Edwards Stores.)

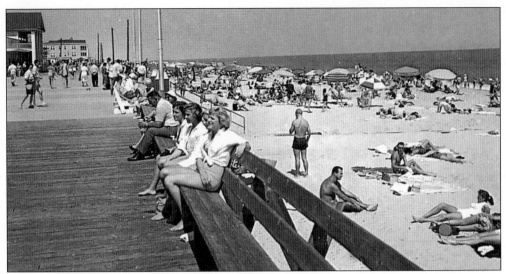

**ALONG THE BOARDWALK, LATE 1950S.** This 1¢ postcard is dated July 2 and was mailed to Mr. and Mrs. Hoffman Glen in Burnie, Maryland. An interesting note is that the card has only the words "Mother & Father" written at the very bottom. (Courtesy of John E. Jacob; publisher: Colortone.)

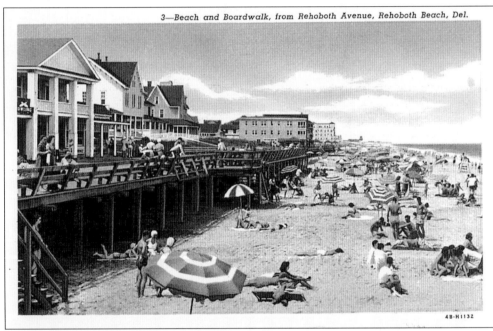

3—Beach and Boardwalk, from Rehoboth Avenue, Rehoboth Beach, Del.

**FASHIONABLE, 1960S.** Broadbent comments that this card is an example of being in the right place at the right time: "One of the girls in this card is the sister of a friend who used to live in Rehoboth around the same time I did, but one of the other cards I sent also had the same girls pictured." He explains that boardwalk photographers were plentiful and charged sufficiently for their services. In his reminiscences, he comments about the "miniature train at the boardwalk amusement park" as one of the many forms of entertainment in the resort. (Courtesy of Alan Broadbent; publisher: Tingle Co.)

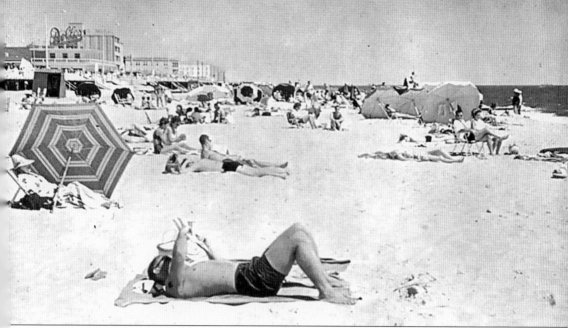

**GREETINGS, C. 1956.** In the background are big, modern, and stylish buildings while in the forefront are small, skimpy bathing suits—indicative of the changing times. The sender writes to someone in Melbourne, Florida, "I'll have the best tan on the maternity floor. The weather has been great and so has the water. I've never been so pampered in my life." (Courtesy of Alan Broadbent; publisher: Snyder & Rodgers.)

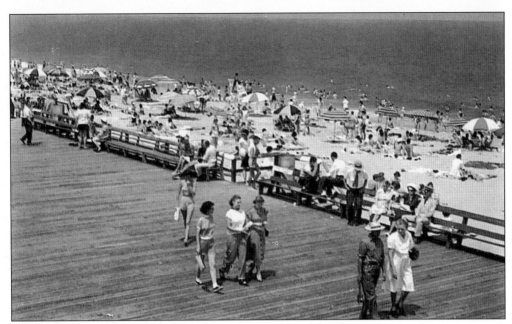

**More Fashionable, c. 1973.** Though many years have passed since most of these postcards were made, basic structures of the town have remained, evident in this view of the boardwalk and its stairway to the sand. (Courtesy of Alan Broadbent; publisher: A. Ken Pfister.)

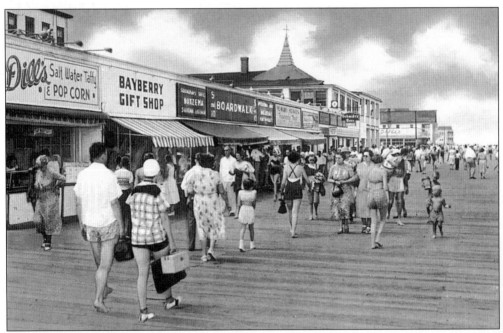

**A Clear Shot, Mid-1970s.** This is an excellent overview of some of the major stores on the boardwalk. Dolles is a hallmark of the resorts and was started by, and is still owned by, the Dolles family. All of the Atlantic coast resorts have regulations about when pets, bikes, and Frisbee playing are allowed on the boards and on the beach. (Courtesy of John E. Jacob; publishers: Harry P. Cann & Bro.)

# *Four*

# STORMS

## CLOBBERING THE COAST

*The joy of beachcombing and surfing the waves quickly becomes a memory if the tides begin to swell and roar, black clouds rumble and roll in, winds spiral and boom, and the floodgates snap open. These are all warning signs of a storm hurdling its way through the ocean to the beach. Visitors huddle indoors, vendors close up shops, and residents batten down the hatches. Weather rampages are always a trade-off at shore resorts, and mean and nasty they can be. Too many buildings have been demolished, too many people have been killed, and too many animals have drowned from northeasters, hurricanes, and even snowstorms raging off the sea. Even with modern meteorological warning systems, ocean tempests have gotten the upper hand on mankind. Monsoon season—which often seems like it will never end—witnesses downpours, high winds, and dismal days, and Rehoboth, as is true with any other coastal town, is a target for these weather terrors.*

*Although Rehoboth has endured its share of tornadoes, blizzards, and storms, the storm of 1962 will go down in history as the worst, right up there with—if not worse than—the hurricanes of 1914, 1917, 1933, and 1944. Because resorts receive the brunt of ocean storms (they unwillingly serve as the buffer for inland towns), they are the victims of millions of dollars in structural damage, drowned loved ones, uprooted cars and boats, demolished homes, banned food and water, and shipwrecked vessels. The following pages will bring home the devastation of what just one storm can do. And one storm—that of 1962—is what this section focuses on.*

*The East Coast experiences hurricanes that hit the shoreline with such ferocity that new bays are often carved out of what once was land. Until only recently, storms could not be predicted with much accuracy or in enough time to allow residents to shore up or batten down or even vacate when necessary. Rehoboth and its surrounding areas are easy targets for roaring gales that crush pleasure and work boats, disentigrate piers and boardwalks, and splinter houses and cottages while drowning animals—even humans at times—as well as cars, tombstones, and buildings. If any interior content has been spared from drowning, then avalanches of mud deposited by the wind and water bury not only goods but precious memories as well.*

*We are grateful for the images granted us by Alan Broadbent, who shot amateur pictures from a Brownie Box camera during and after the storm. We also want to thank the Delaware Coast Press for their insight in sending professionals to the scene to take these incredible photographs, for assembling an outstanding book on the 1962 storm, and for allowing us to reproduce some of their published photos.*

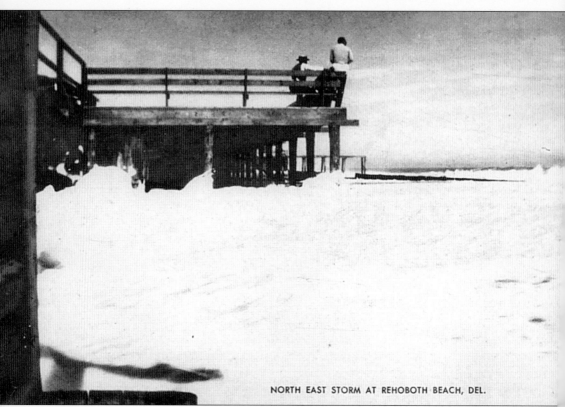

NORTH EAST STORM AT REHOBOTH BEACH, DEL.

**A Northeaster.** "Nor'easters"—usually hitting the coast in early spring instead of summer like hurricanes—are common occurrences along the eastern seacoast, sometimes wreaking as much havoc as the less severe hurricanes. Rain is heavy, winds are high, tides are mountainous, boardwalks are shredded, and shorelines are eroded. Even dauntless, veteran watermen know to stay in during a heavy storm. This Mayrose, New Jersey postcard gives us the view of the ocean faced by those who ventured out on a weakened boardwalk after the storm. (Courtesy of Nan DeVincent Hayes; publisher: The Mayrose Company.)

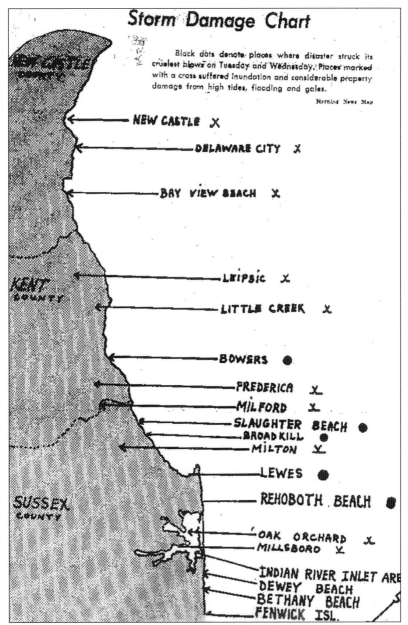

# Storm Damage Chart

Black dots denote places where disaster struck its cruelest blows on Tuesday and Wednesday. Places marked with a cross suffered inundation and considerable property damage from high tides, flooding and gales.

Morning News Map

**NEW CASTLE** X

**DELAWARE CITY** X

**BAY VIEW BEACH** X

**LEIPSIC** X

**LITTLE CREEK** X

**BOWERS** ●

**FREDERICA** X

**MILFORD** X

**SLAUGHTER BEACH** ●

**BROADKILL** ●

**MILTON** X

**LEWES** ●

**REHOBOTH BEACH** ●

**OAK ORCHARD** X

**MILLSBORO** X

**INDIAN RIVER INLET ARE**

**DEWEY BEACH**

**BETHANY BEACH**

**FENWICK ISL.**

NEW CASTLE COUNTY

KENT COUNTY

SUSSEX COUNTY

**THE TERROR.** It has been said that the ferocity of the storm of 1962 has had no equal. The magnitude of the damages sustained by the wind and floods was overwhelming. Although the names "northeaster" and "hurricane" are often incorrectly interchanged, no one debates that the storm of 1962 is appropriately named "The Great Storm." It ripped right up the shore from Cape Hatteras to Cape Henlopen in a 600-mile-long and 300-mile-wide trough with northeasterly winds smashing the east coast at 80 miles per hour and destroying nearly everything in its path. In this chart, the Xs mark the areas less devastated than the areas marked with black dots, where the storm struck with such cruelty and vigor that it took years for the areas to fully recover. Note that the beaches of Bethany, Dewey, Indian River, Rehoboth, and Lewes are counted among the most damaged spots. (Courtesy of Morning News.)

**HEADLINES.** The storm made headlines everywhere not only because of the damage it caused but also because of the exorbitant cost of repairs—$10 million. Other headlines on the front page emphasize the significance of and danger to the brave members of the Coast Guard. As is often the case in the aftermath of a catastrophe, some attempted to take advantage of the situation, indicated by the headline "Four Boys Picked Up for Looting." The newspaper, the second largest in the state, was only 8¢ at that time. (Courtesy of Delaware Coast Press.)

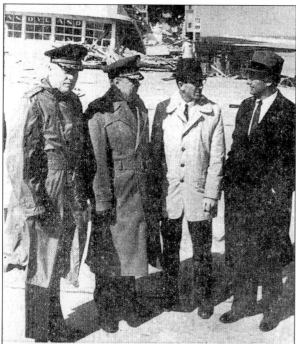

Morning News Photo by Harry A. Lem

REHOBOTH BEACH DAMAGE is surveyed by (left to right) Brig. Gen. Herbert O. Wardell, commanding officer of the 261st Artillery Brigade, Delaware National Guard; Maj. Gen. Joseph J. Scann adjutant general of Delaware; Mayor C. Stamper of Rehoboth, and U.S. John J. Williams, R-Del.

**BIGWIGS.** Storm damages are assessed by top officers of the National Guard, the mayor, and a United States senator. Their attire indicates cool weather and the hats worn by the mayor and senator were classic trademarks of the era. Note the destroyed motel in the background. (Courtesy of Alan Broadbent.)

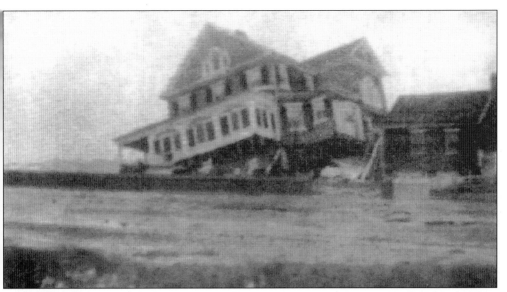

**THA'R SHE GOES.** This image shows the collapse of the Muir house. Located on the corner of Surf and Pennsylvania Avenues, it suffered the battering of waves and wind until flooding resulting in its total disintegration. The house cracked and snapped board by board until every last piece of it was washed out to sea. (Courtesy of Delaware Coast Press.)

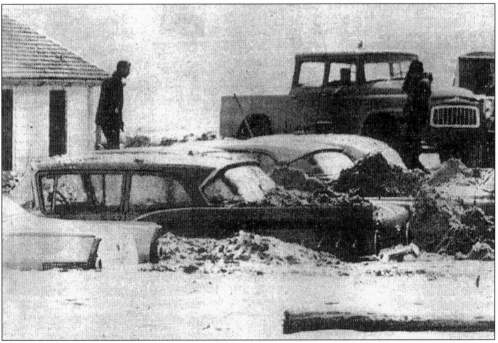

**SINKING CARS.** This photo was taken behind the United States Coast Guard Station at the Indian River Inlet. The Plymouth station wagon partly sank in floodwaters and was also buried under the sand. Alan Broadbent says, "It was ironic that my mother had just sold the wagon to one of the guards just before the great storm; he ended up owning a totaled vehicle." His mother's car is the one on the far right in the photo. (Courtesy of Delaware Coast Press.)

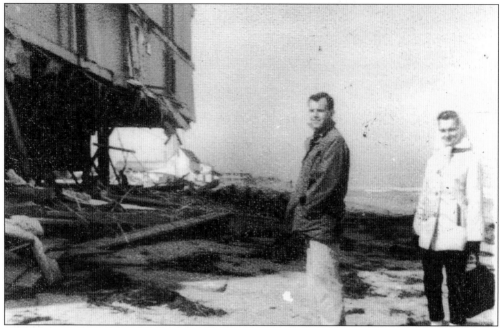

**BROWNIE BOX CAMERA SHOT.** Broadbent admits that his 1950s Brownie Camera may not equal today's high-tech digital cameras, but he still managed to capture the look of despair on his sister Helen's and his brother-in-law John Crockett's faces as they examine an area that was once part of the Royal Surf complex. He remarks, "The interesting portion of this photo was that the framed pictures were still on the living room walls despite the tremendous winds and high storm surges . . . You would really be amazed at how much of the building was lost." (Courtesy of Alan Broadbent.)

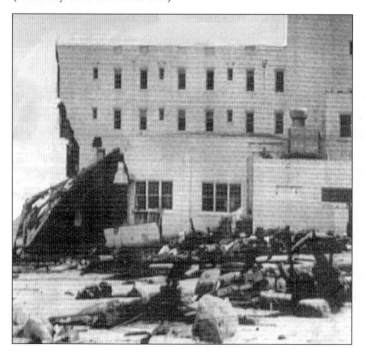

**BOARDWALK UP, THEN DOWN.** This Rehoboth Beach boardwalk did all it could to fend off the brunt of the storm but "The Great Storm of 1962" proved to be too much for it to handle. This photo, taken Wednesday morning during the storm, shows the boards breaking and the pilings collapsing. (Courtesy of *Delaware Coast Press*.)

# *Five*

# BREATHTAKING VIEWS
## WATERWAYS, ROADWAYS, LANDSCAPES

*Although Rehoboth is beginning to see commercialization, it fights to maintain its charm and beauty and offers a host of activities, including shopping. On the perimeter of the ocean hideaway are beacons of flashing lights enticing even the least likely clothes hound or gadget hunter. The outlets are numerous and along with them are a bevy of other independent and franchise operations. But inside the downtown area, merchants aren't "big business"—they are boardwalk concessions, antiquated storefronts, and "mom and pop" shops. Visitors are transported back in time to an old New England village where strangers are friends and friends are kin. This is Rehoboth.*

*But there is more to this seaside town—areas of stunning beauty, points of historical nostalgia, the rolls and peaks of lust-colored dunes, the beauty of the moon or sun reflected off the water, the brilliance of man's ability to contruct bridges and his ingenuity in gapping distances with modes of movement whether they be trains, planes, boats, or cars. This chapter offers a detailed look into the archane and cloaked caches of Rehoboth and its surrounding areas.*

1—Through the Pines on the Highway to Rehoboth Beach, Del.

**A CANOPY OF SECURITY.** Pines and hollies once lined the Rehoboth area, adding to its natural beauty. Postmarked August 8, 1951 to Holmes, Pennsylvania, the card reads, "We are all having lots of fun. The weather has been perfect and the children love the ocean." This view was taken from a helicopter looking east down Rehoboth Avenue towards the beach. (Courtesy of Alan Broadbent; publisher: C.T. American Art.)

71

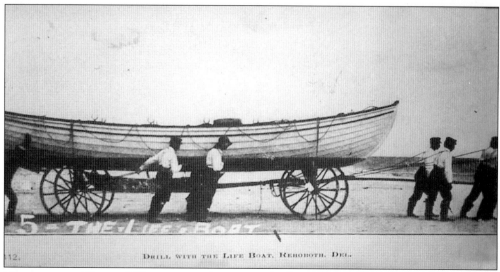

**HITTING THE WAVES.** Of interest are the men in the front of the boat pulling the wagon, and the men alongside and in the back pushing it. This was a typical lifesaving drill for the time in Rehoboth. The Rehoboth Beach Lifesaving Station, which was actually established in what is now Dewey Beach, closed in 1921 and was transformed into a municipal building. The first lifesaving job on the beach—now known as "lifeguarding"—started in 1893. (Courtesy of Anna Hazzard Museum of the Historical Society of Rehoboth Beach, Delaware.)

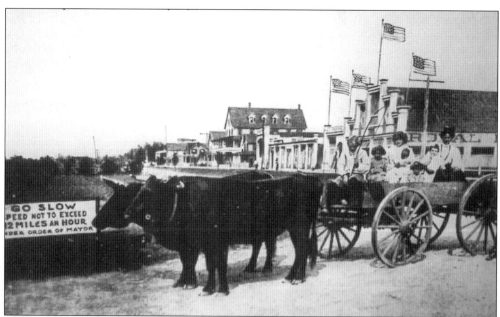

**GIDDY UP!** This picture is of a trolley ride; the Harmon family are the passengers aboard the wagon. The sign at left reads "speed not to exceed 12 miles per hour under order of mayor." The sign on the Horn building behind the riders is "Royal Rol-"; it is cut off where it should read "Horn's Royal Roller Rink." To the left U.S. flags are waving. Until a town ordinance was enacted, cattle were allowed to freely roam the ocean block. (Courtesy Anna Hazzard Museum of the Historical Society of Rehoboth Beach. Delaware.)

**THE DUST NEVER SETTLES.** The card above depicts coarser sand, rougher water, and little foliage in comparison to the card below, which frames a calmer surf, smoother dunes, and more bushes and grass. Between the Surf's Edge and the Atlantic Ocean is high ground while north of it are the flats or the sands which get hit hard by storm tides. It is interesting to note that, in this card, Cape Henlopen State Park has a contiguous shoreline with the highest sand dune between Cape Hatteras and Cape Cod. (Top card is courtesy of Alan Broadbent; publisher: The Mayrose Company; the bottom card is courtesy of John E. Jacob; publisher: Edward Stores.)

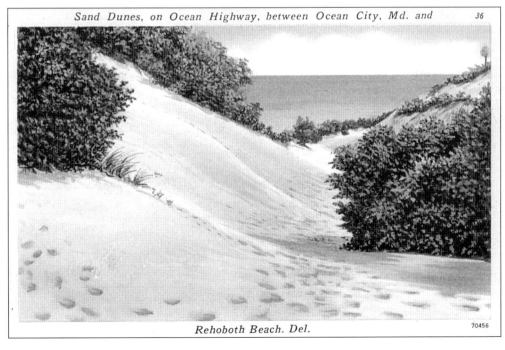

*Sand Dunes, on Ocean Highway, between Ocean City, Md. and* 36

*Rehoboth Beach. Del.* 70456

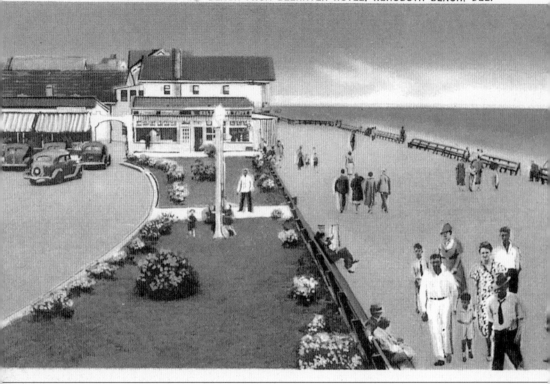

**BOARDWALK AND BEACH.** This postcard shows a view of the boardwalk from the Belhaven Hotel. The Belhaven Hotel is on the corner of Rehoboth Avenue and the boardwalk. (Publisher: The Harry P. Cann & Bro. Co.)

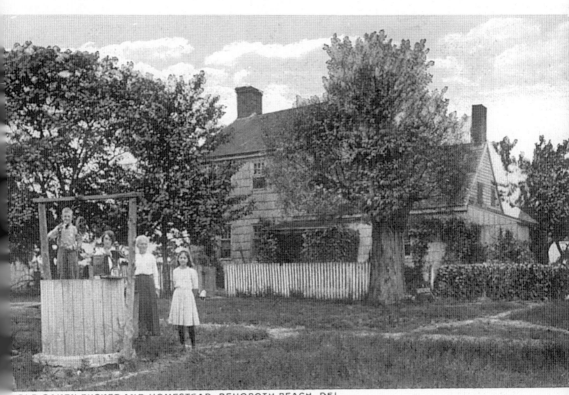

OLD OAKEN BUCKET AND HOMESTEAD, REHOBOTH BEACH, DEL.

**OAKER HOMESTEAD.** Located in Henlopen Acres, this is the Old Oaken Bucket and Homestead owned by the Frazer family. From left to right are William Tyndall, Ella Frazer, Alice Frazer, and Pearl Frazer. Captain Frazer is noted for being the first man from Delaware to graduate from the Coast Guard Academy. This *c.* 1912 image highlights the aging house, full bush trees with their dense trunks, and the old wooden well. (Courtesy of John E. Jacob; publisher: Louis Kaufmann & Sons.)

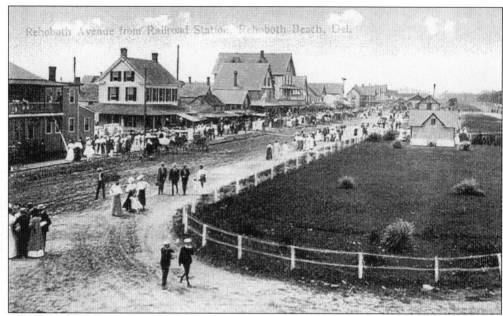

**AND THEY'RE OFF!** Taken from the railroad station, this is a picture of Rehoboth Avenue with the "Flower Garden" or oval. The immediate impression is that of harness racing with humans as the runners. We see the women's long dresses and bonnets and the men in dark suits and hats—common fare for the time. The buildings are uniform with white siding and pink roofs. (Courtesy of Alan Broadbent.)

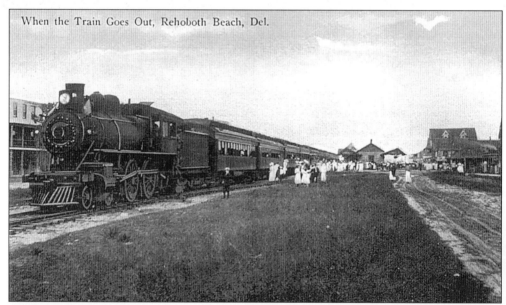

**ALL ABOARD.** The creation of the railroad prompted the construction of shops, hotels, and stables, and led to a significant increase in population. The boardwalk was already in existence, thanks to the Methodist camp. Over time, railroad spurs extended from town to town until the railroad discontinued service in 1928. Originally, visitors to Rehoboth had to arrive in Lewes and then take a horse-drawn surrey to Rehoboth Beach. (Courtesy of Alan Broadbent.)

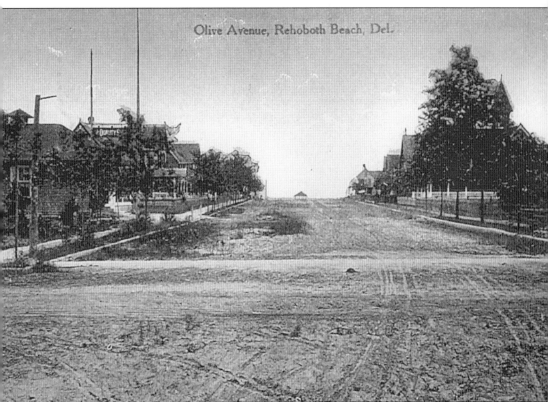

Olive Avenue, Rehoboth Beach, Del.

**EMPTY OLIVE AVENUE.** On the left side of this photo towers a building with the word "quality" written on its roof, and in the background is a structure that looks like a tent or pavilion; the distance and age of the card make it difficult to discern. However, because the hotel is perpendicular to the road and parallel to the ocean, we are led to believe it is Horn's Pavilion. Olive Avenue is sandwiched between Virginia and Maryland Avenues, about three streets north of Rehoboth. (Courtesy of Alan Broadbent.)

**RUSHING TO THE SOUND OF ALARMS.** In 1906, Rehoboth had two chemical fire engines. The fire company was put to the test seven years later when fire destroyed the first blocks of Baltimore and Rehoboth Avenues. In 1923, a volunteer fire department was founded; it grew to have 31 members. Note the types of fire trucks and other emergency vehicles—particularly the Cadillac ambulance. (Courtesy of Alan Broadbent, Publisher, Snyder & Rogers.)

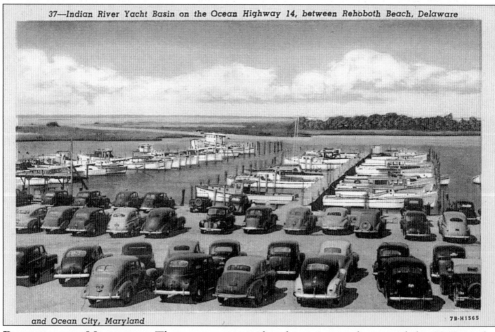

**BOATING AND MOTORING.** These cars suggest the photo was made around the 1940s at the Indian River Yacht Basin. The boats are made of real wood, unlike the plastic ones of today. (Publisher: Harry P. Cann.)

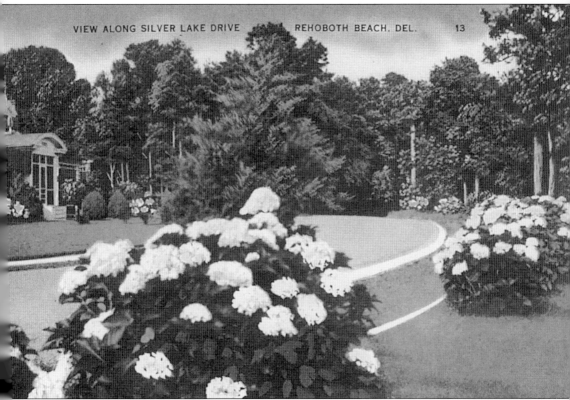

**SILVER LAKE DRIVE.** Beautiful 45-acre Silver Lake is located in the extreme southern end of the town. Lining the area are colorful flowers along a circular lane, quaint bridges, and enchanting gazebos that bring about memories of a time when all that mattered were friends, family, and summer and autumn nights at the lake. The beautiful bridge, built by the Work Projects Administration during the Depression, was originally a walking bridge until it was transformed into the first automobile bridge of the area. (Courtesy of John E. Jacob; publisher: Tichnor.)

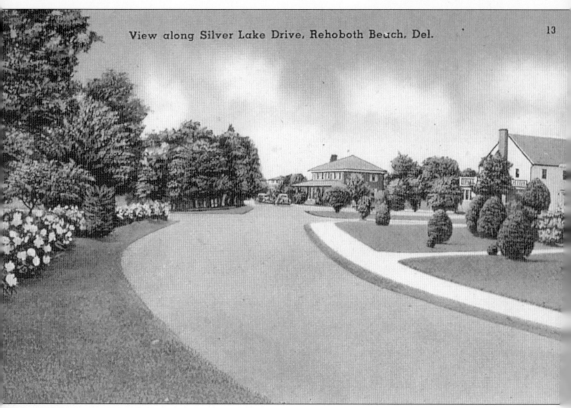

View along Silver Lake Drive, Rehoboth Beach, Del.    13

**SILVER LAKE DRIVE.** This card, postmarked June 6, 1939 at 1 p.m, contains a message to a party in Wilmington, Delaware: "We think we have the best cottage . . . ." The lake dates back to the Ice Age when the ocean was lower than it is today. Someday, the lake may become part of the ocean when the ice caps raise the water enough and oceanic tides erode the land surrounding the lake. (Courtesy of John E. Jacob; publisher: Del Mar News Agency)

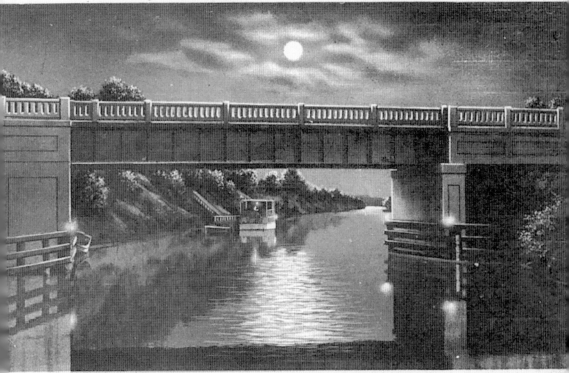

**MOONLIGHT SONATA.** This stunning image depicts the bridge over the Lewes and Rehoboth Canal where the moon peeks from behind dark, puffy clouds and a houseboat sweeps lazily down the canal. The building of the bridge started in 1915 and took many years to complete. It connects the bays of Delaware and Rehoboth. (Publisher: Harry P. Cann.)

**WINGED CHEVY.** This Rehoboth side street looks like something you might see in an old movie. Today resorts have many means of shuttling people where they need to go, but the good old American car remains the staple, even on crowded resort streets. (Courtesy of John E. Jacob; publisher: Breuckmann.)

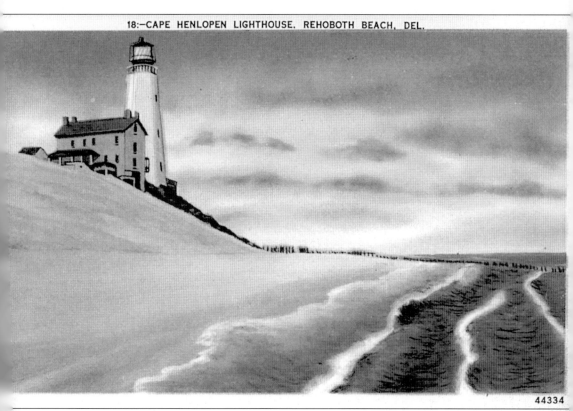

44334

**A BREATH OF BEAUTY.** The Cape Henlopen Lighthouse spirals up to the heavens on a mound of sand. Before toppling into the Atlantic Ocean in 1926, it guided ships around perilous shoals. Delaware officials—wanting a full-scale replica of the 1765, 70-foot, 3-inch beacon lighthouse—claimed that it would cost nearly $11 million to rebuild, which would include a keeper's house and oil vault. Iinsufficient funding, the argument that the beam would interfere with current navigational systems, and the fact that not all residents are applauding the idea has slowed progress to the realization of a full-scale duplication. (Courtesy of Alan Broadbent; Publisher: The Harry P. Cann & Bro. Co.)

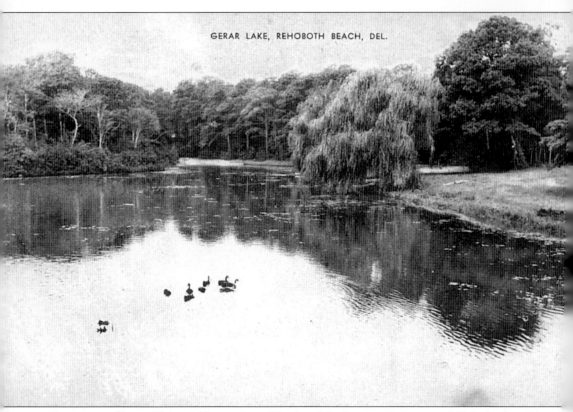

GERAR LAKE, REHOBOTH BEACH, DEL.

**DUCKS ON GEAR.** This wishbone-shaped body of fresh water is in central Rehoboth, with Rehoboth Avenue on its south side, Seaview Park on its north side, and Central Park at the northwest end. Migrating waterfowl skim and skirt the lake as youngsters play on its "children's bridge." (Courtesy of John E. Jacob; Publisher: The Mayrose Co.)

# Six

# AMUSEMENTS
## FUN IN THE SUN

*In 1855, an industrious fellow named Richard West touted Rehoboth Beach as "A Summer Retreat and Bathing Place" in handbills that he used to advertise land for sale in Rehoboth. Unfortunately, very few people were interested in buying property at that time. It was not until 1872 that 414 acres were purchased by the Religious Founders for Camp Meeting Grounds. The following year Rehoboth Beach would see its first hotel, The Surf House, along with its first boardwalk. In 1903, the first beach concession, famous Horn's Pavilion, was finished and became the main gathering place for amusement. Horn's had a theater, an ice cream parlor, a store, and a pier that extended 150 feet into the ocean.*

*Today, one of downtown Rehoboth's greatest assets is the mile-long boardwalk, which is a terrific place for long walks, rollerblading, and bike riding. Youngsters enjoy waterslides, miniature golf, arcades, go-carts, and the small amusement park. Older folks may enjoy those activities as well or listen to a live concert at the bandstand during the summer. Abundant festivals and activities also take place throughout the year including the Sea Witch and Fiddlers Festival, Pumpkin Chunkin Contest, the Film Festival, and the Polar Bear Plunge.*

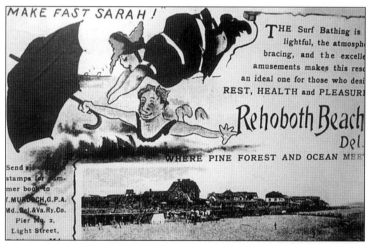

**MAKE FAST SARAH.** This ad for Rehoboth states, "The Surf Bathing is delightful, the atmosphere bracing, and the excellent amusements make this resort an ideal one for those who desire REST, HEALTH and PLEASURE." (Courtesy of the Anna Hazzard Museum of the Historical Society of Rehoboth Beach, Delaware.)

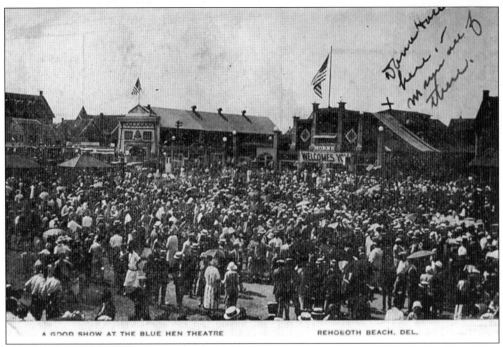

**SPECTATORS GATHER AT THE SHORE.** This crowd gathers to see a show at the Blue Hen Theater, which was owned by Charles Horn Jr. The theater attracted hordes of people. (Courtesy of John E. Jacob; publisher: Horns.)

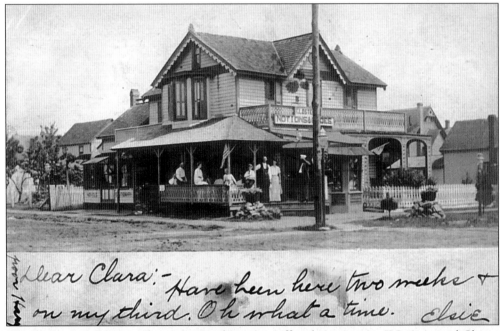

**NOTIONS AND SHOES.** The signs on this store offer their patrons "Notions and Shoes, Novels, and Stationary." In the early 1900s, "notions" was a term used for sewing needles, buttons, and threads. This postcard is dated 1906. (Courtesy of John E. Jacob.)

86

**PARADE.** An undated photograph depicts a parade on Rehoboth Avenue. The parade proceeds past Horn's, which is the first building on the right. Parades still continue today in Rehoboth as seen on page 96. (Courtesy of the Delaware Public Archives.)

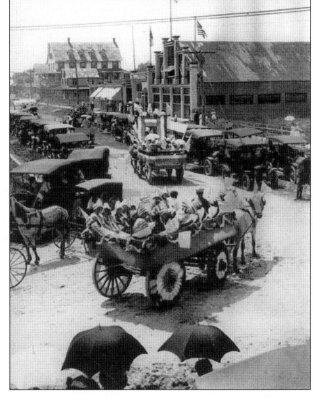

**BOARDWALK.** Ladies stroll the boardwalk using their bonnets and umbrellas to keep the sun off their faces. If one had a tan in the early days it was considered lower class as people with tans were certainly not ladies of leisure. (Courtesy of Delaware Public Archives.)

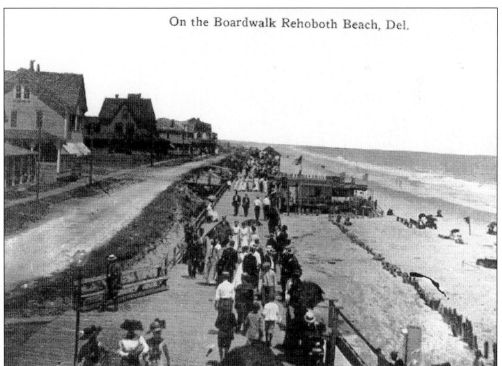

On the Boardwalk Rehoboth Beach, Del.

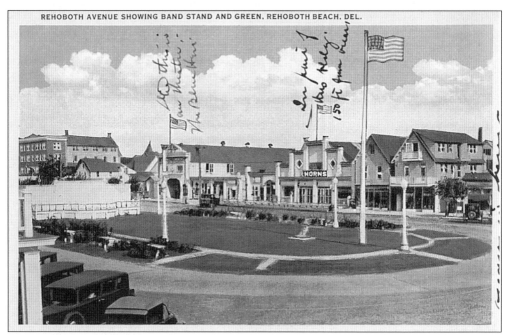

**BANDSTAND.** Many summer nights are filled with the sounds of various bands playing for the patrons of Rehoboth. The owner of this postcard points out where the ocean is and that Horn's is a mere 150 feet from the ocean. (Courtesy of John E. Jacob; Publisher, Horns, Inc.)

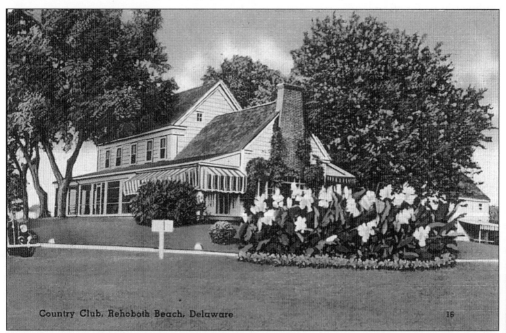

Country Club, Rehoboth Beach, Delaware                          16

**COUNTRY CLUB POSTCARD, 1946.** This country club moved after the storm of 1962. The new country club, founded in 1960, offers an 18-hole golf course, tennis courts, a swimming pool, and a restaurant privately owned by the members. (Courtesy of John E. Jacob; publisher: Del Mar News Agency.)

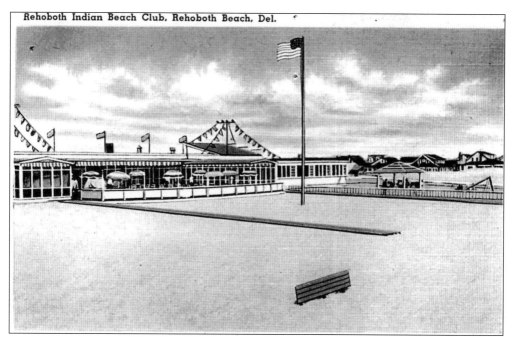

**INDIAN BEACH CLUB.** Once located on Rehoboth Beach, this club no longer exists. It offered a place to sail, an outdoor café, and a play area. Today, the Rehoboth Bay Sailing Association (RBSA) provides a full program of social events, tennis clinics and tournaments, regattas, and a sailing school for all ages. (Courtesy of John E. Jacob; publisher: Edward Stores, Inc.)

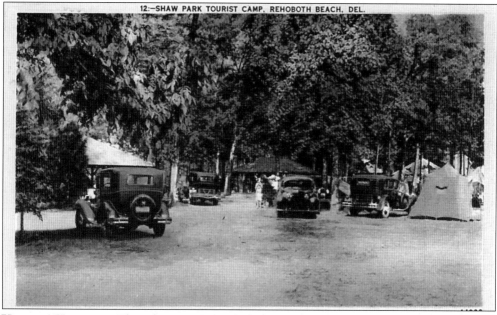

12:—SHAW PARK TOURIST CAMP, REHOBOTH BEACH, DEL.

**VINTAGE VEHICLES.** These luxury 1920 vehicles are at Shaw Park campground, where tents and trailers coexisted. The park is located on Rehoboth Avenue by the canal. The city owns the land and allows tourists to stay only during the summer—the water to the park is turned off during the winter. (Courtesy of John E. Jacob; publisher: Harry P. Cann & Bro. Co.)

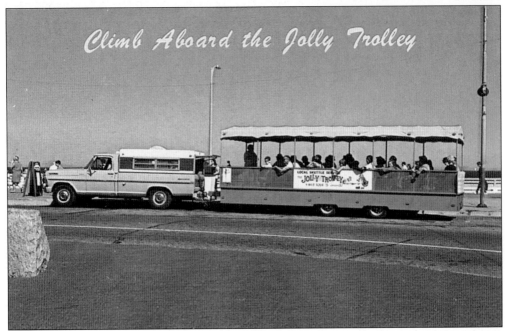

**LOCAL SHUTTLE.** The Jolley Trolley is the local shuttle offering a narrated 10-mile tour between Rehoboth and Dewey Beach. Passengers can get on or off anywhere along the route. The shuttle runs between Memorial Day and Labor Day. (Courtesy of John E. Jacob; publisher: Rodgers.)

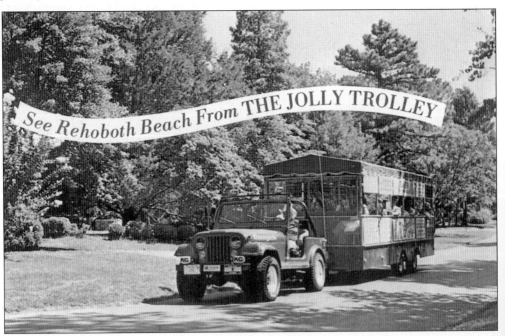

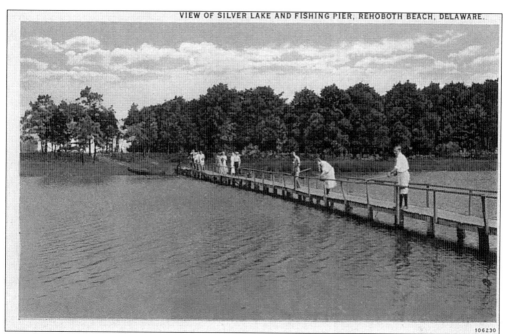

106230

**FISHING ON THE LAKE.** Boys fish from the pier at Silver Lake, which separates Dewey and Rehoboth Beach. The whole town used to ice skate on the lake in the winter. Some locals would watch for Canadian geese that often got caught in the ice; they would chip them out and eat them for supper. (Courtesy of John E. Jacob; publisher Louis Kaufmann & Sons, Inc.)

**LAKE GERAR.** This fishing bridge entertains many a youngster during the summer. Alan Broadbent remembers catching small painted turtles the size of half-dollars as he floated in his inner tube on lazy summer days. (Courtesy of John E. Jacob; publisher: Tingle Print Co.)

**CONVENTION AND CIVIC CENTER.** The Rehoboth Beach Convention Center measures 6,900 square feet and seats 900 people. Many functions, including the Miss Delaware Pageant, the Jazz Festival, and the Sea Witch and Fiddler's Festival, are held here. The center boosts Rehoboth's economy as people come from all over to enjoy the events. (Courtesy of John E. Jacob; publisher: E. Farthing.)

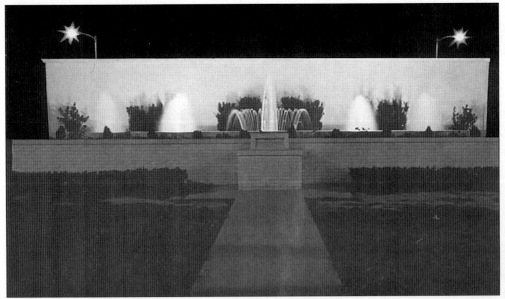

**STUNNING FOUNTAIN.** The Chamber of Commerce erected this fountain in 1963 on Rehoboth Avenue at the boardwalk. It is the only one of its kind in Rehoboth. Clear water spouts in the middle and on either side gush yellow-lighted sprays. (Courtesy of Alan Broadbent; publisher: Tingle Print Company.)

**REHOBETH ART LEAGUE.** Located in picturesque Henlopen Acres, this facility hosts year-round workshops for adults and children, lecture series, concerts, and exhibitions. A Cottage Tour is available the second week in July and an Outdoor Art Show takes place on the second and third weekends in August. (Courtesy of John E. Jacob; published by J.B. Moll, Jr.)

CORKRAN STUDIO
from Bayberry Bend Walk.

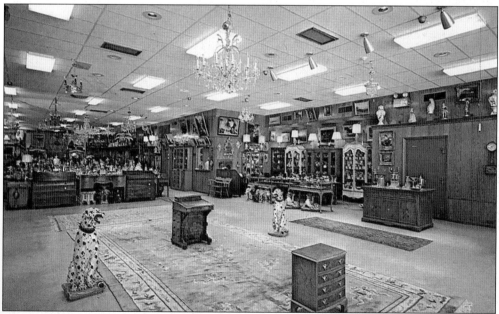

**STUART KINGSTON GALLERIES.** Stuart Kingston is a privately owned family business that began in 1930. The company carefully hand-selects all of their merchandise to ensure that only pieces of the finest quality can be found in their stores. They are leading importers of decorative items, furniture, fine art, precious gems, oriental rugs and carpets, and collectibles. (Courtesy of John E. Jacob; Publisher: Crystal Color Productions.)

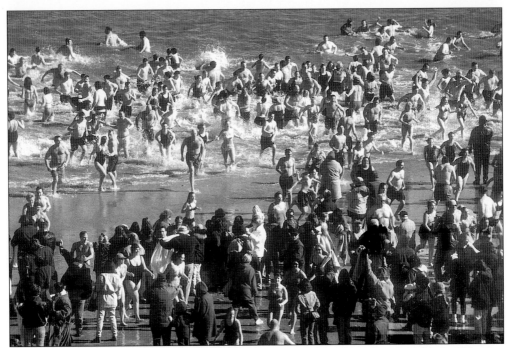

**POLAR BEAR PLUNGE.** The annual Polar Bear Plunge takes place on a Sunday in February at 1 p.m. Over 1,000 plungers jump into the icy water to raise money for the Special Olympics Delaware. The hearty gentleman below proudly wears his bear cap before boldly jumping into the frigid Atlantic Ocean in February. (Photos courtesy of the Rehoboth Beach Chamber of Commerce.)

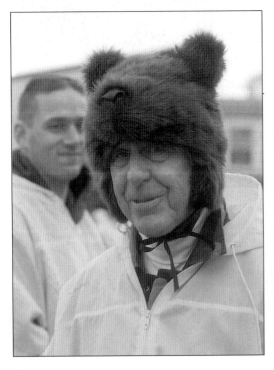

**SEA WITCH HALLOWEEN & FIDDLERS FESTIVAL.** The Sea Witch Festival is named after the *Sea Witch,* a clipper ship that roamed the waters in the late 1700s. The festival itself includes a parade and a fiddlers contest (see below) with prizes for the winning participants. Other events include horse shows on the beach, a broom-tossing contest, a sea witch-hunt, and a best-dressed pet contest. In recent years, a turtle has come disguised as a tennis ball and the collie pictured here is relaxing in his witch hat. (Photograph courtesy of Rehoboth Beach Chamber of Commerce.)

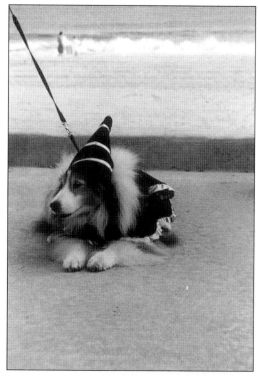

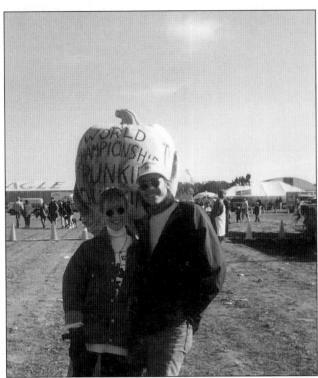

**PUNKIN CHUNKIN.** A couple stands in front of a giant pumpkin at the 15th annual World Championship Punkin Chunkin Contest. In 2000 the group gave $10,000 worth of scholarships to area students. The pumpkins are placed on various machines and catapulted into the air to see which pumpkin can be shot the farthest. One pumpkin actually flew 3,900 feet out of the barrel of a machine called the Old Glory. (Courtesy of Julie Brewington.)

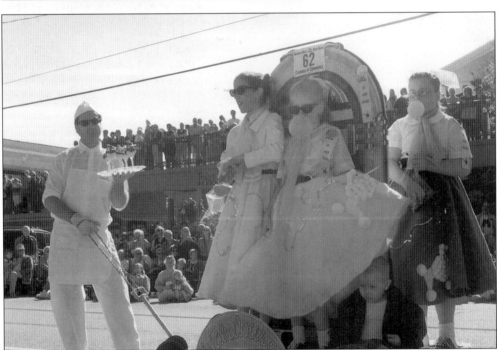

**PARADE.** This 1950s soda shop float stops before the judge stand as the girls in their poodle skirts blow pink bubbles. One member of the float looks to be someone's baby brother, hiding under a skirt in his leather jacket. (Courtesy of Rehoboth Beach Chamber of Commerce.)

# Seven
# DENIZENS
## PEOPLE, PLACES, AND PORTALS

*Native Americans were the earliest people to enjoy the plentiful seafood and summers at Rehoboth Beach. English and Dutch settlers arrived between 1650 and 1675 and farmed the land. Slave labor took care of the plantations that produced tobacco, wheat, strawberries, and corn. In 1873, Robert Todd formed the Rehoboth Camp Meeting Association and the town was laid out in the fan-shape design of today. In the spring of 1873, engineers and workmen laid out the roads, lots, and parks and generally improved the land. By July of the same year, many cottages were being constructed and hundreds of lots had been sold. The Methodist camp meeting ground was by the canal nestled in the pines.*

*Between 1884 and 1878, more tourists were drawn to the area with the advent of the railroad, the boardwalk, Hotel Henlopen, and a post office. Rehoboth was well on its way to becoming the resort it is today. This chapter is about some of the places, roadways, and people of Rehoboth.*

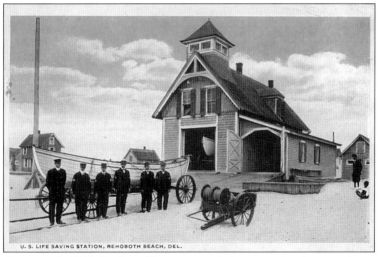

U. S. LIFE SAVING STATION, REHOBOTH BEACH, DEL.

**LIFE SAVING STATION.** In 1849 the first efforts were made by our national government to establish a procedure to aid shipwreck victims and prevent the multitude of shipwrecks. In 1878 a lifesaving station was opened in Rehoboth Beach. The stations built at this time cost about $2,400 to complete. Conditions were hard and equipment was primitive; many of them men worked for $1.33 per day and did not have much of a family life. They had weekly drills and kept in excellent physical shape. These men are some of the unsung heroes of the community, risking their lives in numerous surf rescues. (Postcard courtesy of John E. Jacob; publisher: Louis Kaufmann and Sons.)

THE RAILROAD COACH AMONG THE PINES, REHOBOTH BEACH, DELAWARE.

52194

**RAILROAD COACHES.** Folks in Rehoboth actually lived in these cozy railroad coaches. The postcard below shows a home located on Henlopen Avenue. The railway car shown above is nestled in trees and protected by a fence. The people cooked on kerosene stoves and had iceboxes for refrigerators. (Courtesy of John E. Jacob; publisher: Harry P. Cann & Bro. Co. & Louis Kaufmann and Sons.)

6:—THE CAR AMONGST THE PINES, REHOBOTH BEACH, DEL.

44322

98

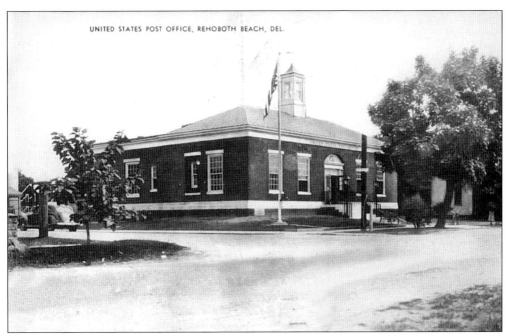

**POST OFFICE.** The first post office made its appearance in 1873. Earlier post offices were located in people's homes. Locals would gather and chat while mail was sorted. Later, residents acquired post office boxes and had to go pick up their mail. (Courtesy of John Jacob; publisher: The Mayrose Company.)

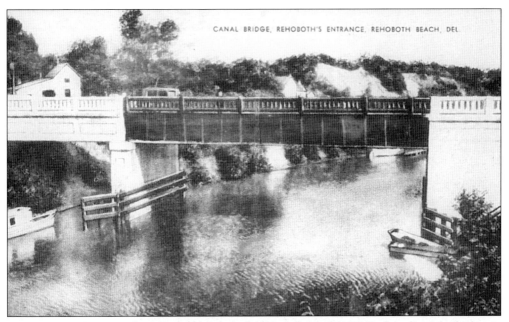

**BRIDGE OVER CANAL.** The Lewes and Rehoboth Canal, finished in 1915, flows into the harbor in Lewes and on into Rehoboth Bay. The canal was known as "Whorekill" until 1658. It has been theorized that the name was given to the canal by fur traders and explorers. Perhaps it was the Dutch who originally named it Hoerekill or Harlot's River. When English became the prevalent language it was pronounced Whorekill. (Courtesy of John Jacob; publisher: The Mayrose Company.)

**HENLOPEN YACHT BASIN.** Locals have always considered this yacht basin to be part of Rehoboth. (Courtesy of John E. Jacob; publisher: Tingle Print Company.)

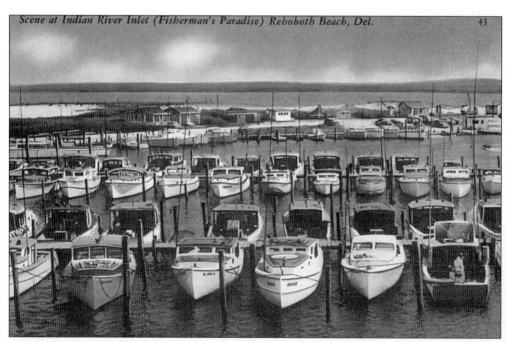

*Scene at Indian River Inlet (Fisherman's Paradise) Rehoboth Beach, Del.* 43

**INDIAN RIVER INLET.** Numerous boats fill the slips in this "fisherman's paradise." Today the marina has 295 slips and is home to many private fishing boats, charter boats, and head boats. Bluefish, flounder, and stripers can be found in the inlet and bay. For those who want to venture into the Atlantic there are dolphin, tuna, sharks, and marlin. (Courtesy of John E. Jacob; publisher: Rehoboth 5 & 10.)

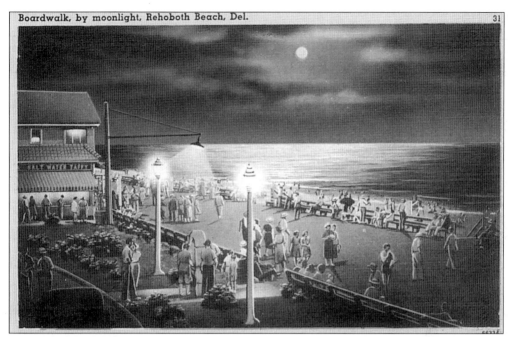

**BOARDWALK AT NIGHT.** The concession stand sits on the corner of the boardwalk and Rehoboth Avenue. The people on this postcard are enjoying the night air, strolling or sitting along the boardwalk, and others are taking advantage of the moonlit night, playing and walking on the beach. (Courtesy of Alan Broadbent; publisher: Carlin & Kremer.)

**COLUMBIA AVENUE.** Note how tall the trees are and how the skyline embraces them. Located between Henlopen Acres and the North Shore area, Columbia Avenue is now a bustling residential area. (Courtesy of John E. Jacob; publisher: Horns, Inc.)

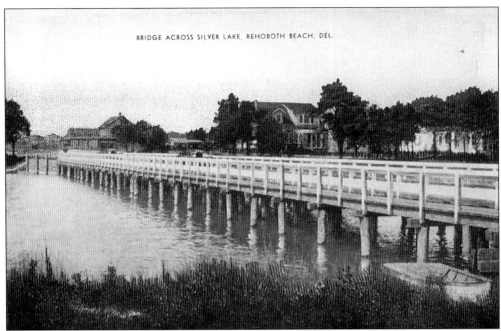

BRIDGE ACROSS SILVER LAKE, REHOBOTH BEACH, DEL.

**SILVER LAKE BRIDGE.** The Silver Lake Bridge was originally a fishing bridge in the early 1900s. Changes took place over time as light poles were added and the bridge railings were replaced. (Postcard above courtesy of John E. Jacob, publisher: L.H. Roth; postcard below courtesy of John E. Jacob, publisher: Edward Stores, Inc.)

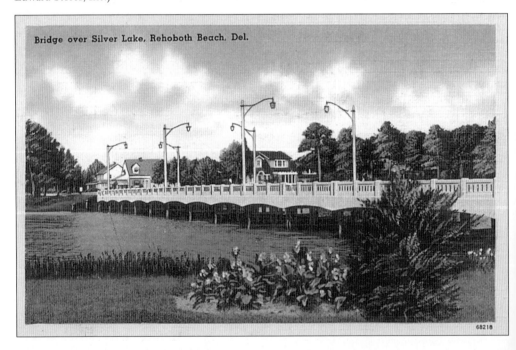

Bridge over Silver Lake, Rehoboth Beach, Del.

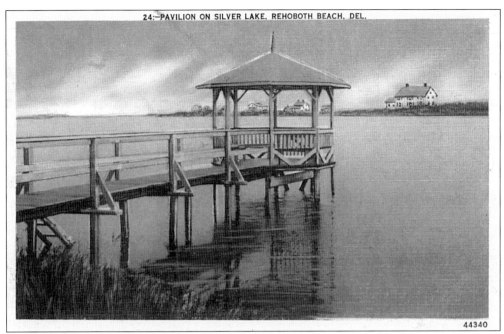

44340

**PAVILION ON SILVER LAKE.** An inviting place to enjoy an afternoon, the lake is 45 acres of freshwater dotted with privately owned gazebos. It is common to come across a bright green exotic Monk parakeet around this lake. These birds escaped from a boat heading toward New York in the 1970s. They have yellow bellies, pale-gray chests and foreheads, and are about 11.5 inches long. Their largest communal nest is in a tree on Silver Lake Drive. (Courtesy of John E. Jacob; publisher: Edward Stores, Inc.)

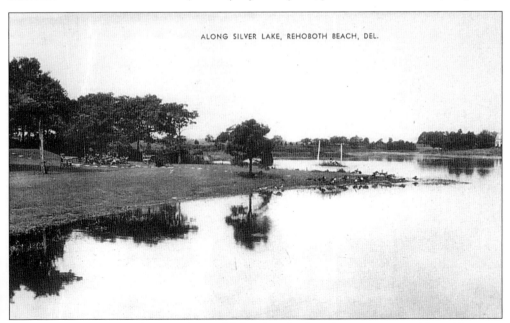

ALONG SILVER LAKE, REHOBOTH BEACH, DEL.

**SILVER LAKE.** Silver Lake, designated as a wildlife refuge, has been home to carp, catfish, and bass over the years. A large amount of building has occurred, and while the catfish and carp are still in the lake the bass are now scarce. (Postcard courtesy of John E. Jacob; publisher: The Mayrose Publishing Co.)

**BESS HENON, 1908.** Bess Henon, posing for this photo in a fashionable bathing suit, was a frequent summer visitor to Rehoboth Beach. In 1949, her family moved to Rehobeth from Springfield, Pennsylvania. The family originally lived at 10 Laurel Street and eventually moved to 120 Norfolk Street. (Courtesy of Alan Broadbent.)

**BATHING BEAUTY.** The first beauty contest in the United States was held in Rehoboth Beach in 1880. Ms. Myrtle Meirwether of Shinglehouse, Pennsylvania won the crown. (Courtesy of the Anna Hazzard Museum of the Historical Society of Rehoboth Beach, Delaware.)

**CHRISTMAS ALL YEAR LONG.** These rare Christmas cards are handmade by Teddie Tubbs. The card at the bottom of the page depicts the kind of geese that are very prominent in the region. (Courtesy of Alan Broadbent.)

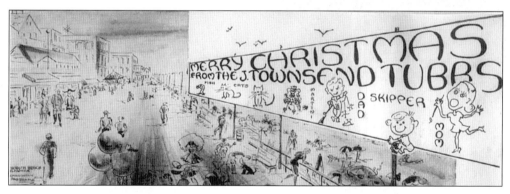

**TWENTY DELAWARE AVENUE.** Mrs. John F. King is pictured here with her grandmother, Isabella Lynch, on the steps of 20 Delaware Avenue. Mr. and Mrs. Francis E. Lynch owned the home from 1920 until 1924. King, who is five years old in this photo, remembers many happy summers spent in the cottage. The cottage eventually became the Blue Poodle Hotela (see page 120). Francis E. Lynch is shown below enjoying a relaxing afternoon on the boardwalk. (Courtesy of Mrs. John F. King.)

BOTH 8869

# GUY AMMON
### 120 NORFOLK ST.
### REHOBOTH BEACH, DEL.

*manufacturer of*

LURA-BAIT WITH
T. M. REG. THE
Underwater Decoy OFF-SET
H K
O O

PATENT 2,616,206

ORDER NO.

R ORDER NO.

SOLD TO

8: NET CASH

LURA-BAIT. This invoice is from Guy Ammon's Lura Bait Company. Mr. Ammon handmade lures from balsa wood and fur or hair. Later Ammon went on to use Styrofoam balls, monofilament, and lacquer, all made by Dupont. The lures had a special offset hook (two hooks with bait stretched between them) and he sold them locally. Mr. Ammon's business was sold after his death and many of his original rods, reels and lures fell victim to the 1962 storm. (Courtesy of Alan Broadbent.)

**ALAN BROADBENT.** Broadbent, who spent many years in Rehoboth Beach, is shown here posing for his Florida Air Academy picture. Broadbent went on to become a crew chief with the Firelands Museum of Military History. (Courtesy of Alan Broadbent.)

# *Eight*
# LODGING
## A PLACE TO PUT YOUR HAT

*Early housing in Rehoboth consisted of frame structures covered with basic bald-cypress sheathing. The people who inhabited these homes were the small number of farmers who lived in the area in the 17th and 18th centuries. These farmers produced crops like tobacco, wheat, and corn. In 1855, Robert West had a vision of making Rehoboth into a seashore resort. Later that year, Joseph P. Comegys Esq. formed an association with West and created a "Plan of Rehoboth Beach." In 1872, the Rehoboth Beach Camp Meeting Association of the Methodist Episcopal Church purchased beachfront land, laid out the streets, and had the railroad extended from Lewes to Rehoboth.*

*The original camp meeting houses were wooden and consisted of one room and a porch downstairs, and another room upstairs. Two-room models also became available. These meetinghouses were known as wooden "tents" and could be leased for a 10-day period for $20. Canvas-wall tents were also available which rented for $8. More people became attracted to the region and in 1873 the first hotel was built. A post office was also established. The Douglas House, built in 1877, was another early establishment offering 60 rooms for rent and including a shuffleboard, a bar, and dances every Saturday night. This was the center of social life for the community until 1902 when it was destroyed by fire.*

*From 1925 to 1929 with the advent of cars and the help of a modern highway that was constructed from Rehoboth to Georgetown, Rehoboth's popularity soared. With this newfound appeal, the summer retreat saw a real estate and building boom. The 1920s saw the start of many suburban developments, hotels, and rooming houses that only lulled for a short period during World War II and then continued to flourish.*

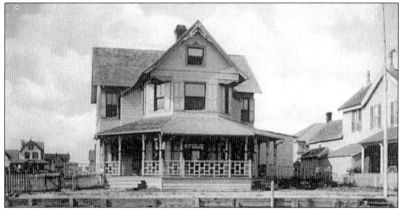

**MINQUA COTTAGE.** This early 1900s postcard depicts the Minqua Cottage located on the beach. A car can be seen in the left-hand corner behind the fence. Upon inquiry the author was told the cottage no longer exists as it may have been destroyed in the 1914 storm. (Postcard courtesy of John Jacob.)

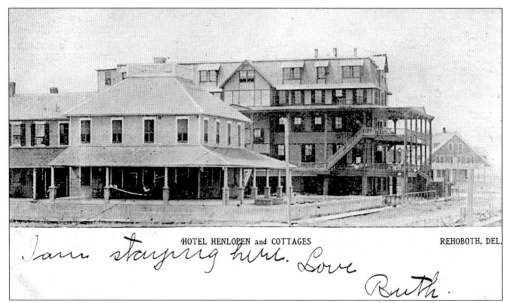

HOTEL HENLOPEN and COTTAGES          REHOBOTH, DEL.

*I am staying here. Love Ruth.*

**HENLOPEN HOTEL, SUMMER OF 1907.** This hotel was established in 1879 and had 75 rooms that could be rented for $10 a week. The Henlopen is the large building in the middle of this postcard. (Courtesy of John Jacob.)

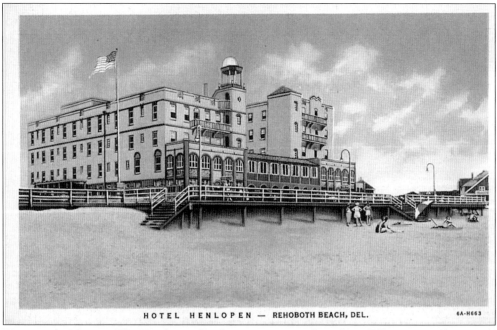

HOTEL HENLOPEN — REHOBOTH BEACH, DEL.          6A-H663

**HENLOPEN HOTEL.** The Henlopen has been restructured on four different occasions since 1879. Many nationally prominent people, including former president Richard Nixon, have been guests at the hotel. Beach chairs, umbrellas, and fishing equipment are available at the beach club for the guests. (Courtesy of John Jacob.)

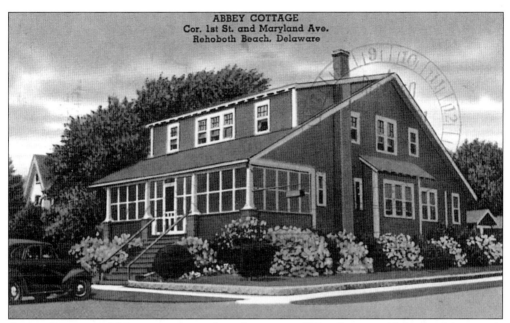

**ABBEY COTTAGE.** This cottage, located on the corner of First Street and Maryland Avenue, is open during the summer for vacationing guests. This 1961 postcard was sent from a man named Larry to his friend at the Bureau of Employment Security in Pennsylvania, telling her that he was having a great time but the beach was a little crowded. (Courtesy of John Jacob; publisher: Tichnor Brothers, Inc.)

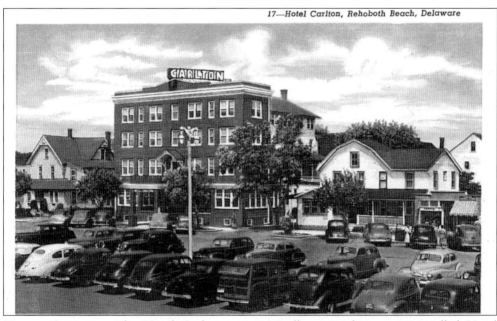

**HOTEL CARLTON.** The Hotel Carlton was originally a wooden structure called Hotel Brayton. The hotel was eventually remodeled and a brick face was put on the building. In the 1970s, the building was declared unsafe. (Postcard courtesy of John Jacob's collection; publisher: Harry P. Cann & Bro. Co.)

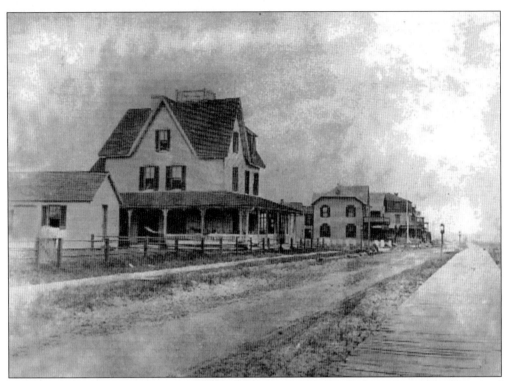

**COTTAGES ON THE AVENUE, C. 1950.** The postcard above depicts the early cottages of Reboboth Beach. (Photo above: Courtesy of the Dover Public Archives) (Postcard below: courtesy of the collection of John E. Jacob; publisher: Louis Kaufmann & Sons.)

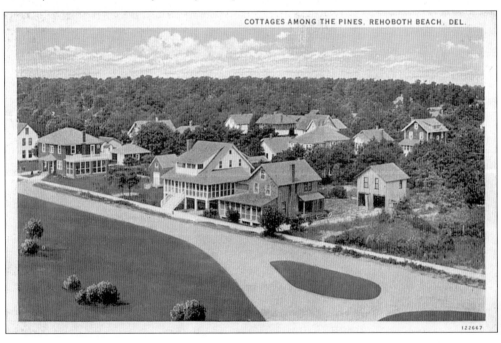

COTTAGES AMONG THE PINES, REHOBOTH BEACH, DEL.

122667

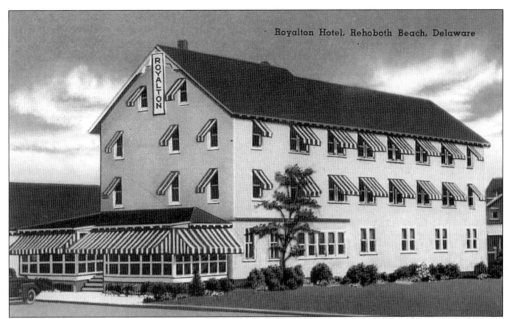

**ROYALTON HOTEL.** This postcard was sent from Rehoboth Beach to Pennsylvania with a 2¢ stamp. Delta, the sender, seemed to be enjoying herself despite the "few drops of rain" she writes about (see below). (Courtesy of John E. Jacob; publisher: Tichnor Brothers, Inc.)

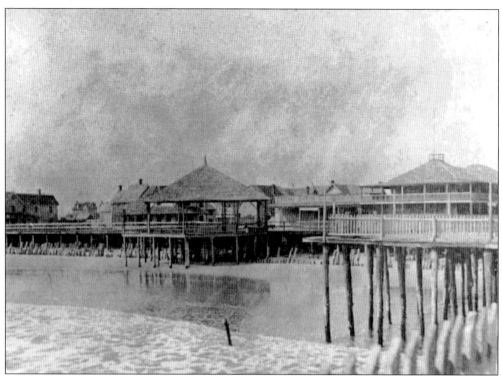

**BELHAVEN BY THE OCEAN.** The Belhaven Hotel, situated on the corner of Rehoboth and the boardwalk, was known as one of the finer hotels in the area. It was originally called the Casino Hotel (pictured above) and was changed to the Belhaven in 1912. The hotel was shut down sometime after the 1962 storm. (Above courtesy of the Dover Public Archives; below courtesy of John E. Jacob, publisher: The Harry P. Cann & Bro. Co.)

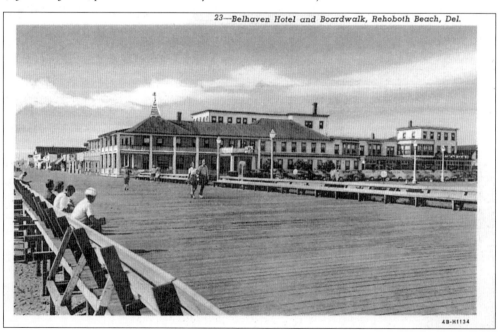

23—Belhaven Hotel and Boardwalk, Rehoboth Beach, Del.

4B-H1134

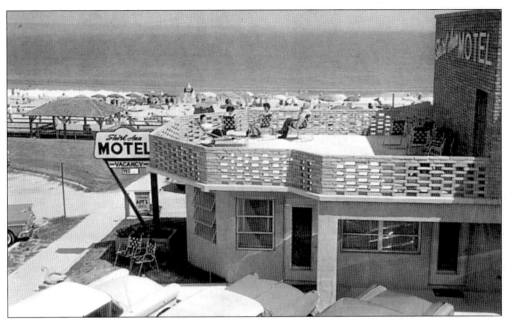

**SHIRL ANN MOTEL.** The Shirl Ann Motel was purchased by the Zerby family in the late 1950s. In 1989, the hotel was demolished and the doors did not reopen until May of 1991 under the new name of the Boardwalk Plaza Hotel. The hotel's furniture, fixtures, and décor were chosen by Mrs. Zerby. In 1992, the hotel received the prestigious four-diamond award from the AAA and has won the award several times since. (Courtesy of John E. Jacob; publisher: Coulor Pictures Publishers, Inc.)

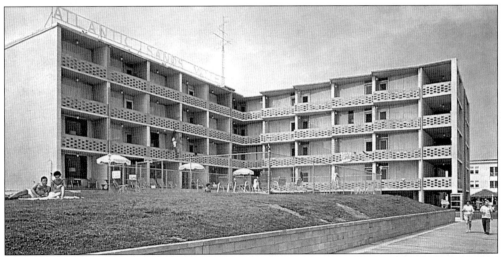

**ATLANTIC SANDS HOTEL.** The Atlantic Sands Hotel, located on the boardwalk with a grand view of the ocean, was originally built in 1959 and was partially ripped apart by the hurricane of 1962. Upon rebuilding, the Sands had an additional 34 rooms and in 1985 another 32 rooms were added. The hotel was family owned until 1985 and is currently under renovation by new owners who are adding 78 new suites and 12,000 feet of meeting space for conference rooms. A fitness center, outdoor pool, hot tub, and an oceanfront restaurant and bar will also be available to patrons. (Courtesy of John E. Jacob; publisher: A. Ken Pfister.)

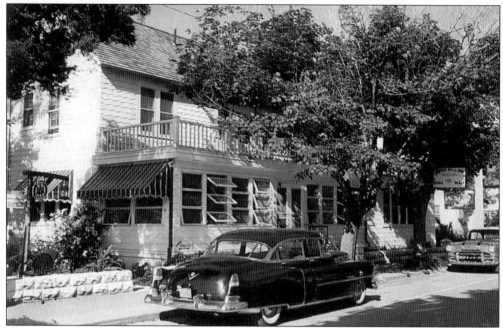

**DINNER BELL INN.** Established as a restaurant in 1938, the Dinner Bell served 1,000 meals a day. The inn was added in the late 1960s with 25 rooms, which are now being remodeled. The restaurant has been removed to make way for additional rooms. The English garden, started by Mrs. Ruth Emmert (the founder of the Dinner Bell), will also be expanded. The remodeled Dinner Bell will include a new conference room, sunroom, and library. The inn is now owned by Chad Moore's family. (Courtesy of John E. Jacob; publisher: Chuck West.)

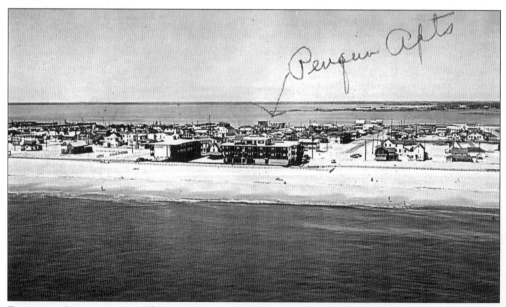

**PENGUIN APARTMENTS.** This apartment complex was a lovely place to live until the storm of 1962. Unfortunately, the building was demolished by the storm and the families living there lost most of their belongings. (Courtesy of Alan Broadbent; publisher: E. Farthing.)

116

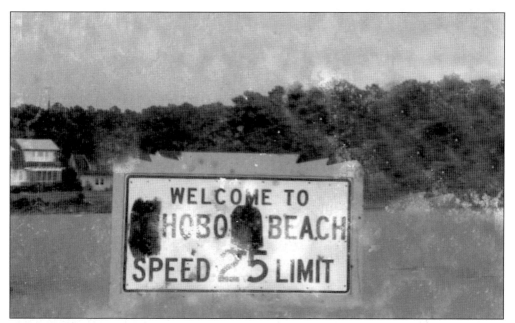

**HOBO BEACH SIGN.** Someone spray-painted over the letters on this Rehoboth Beach sign so it reads "Welcome to Hobo Beach Speed Limit 25." According to Alan Broadbent, the hotel below was named Hobo Hotel after this humorous street sign. (Courtesy of Alan Broadbent.)

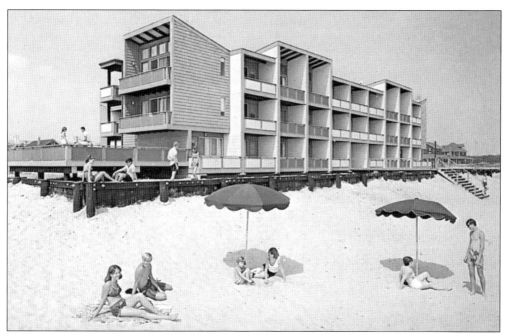

**HOBO HOTEL.** Located at 1 Clayton Street, this oceanfront hotel is open only during the summer months. The hotel has 45 units, private balconies, a swimming pool, and a coffee shop. (Courtesy of Alan Broadbent; publisher: Aladdin Color.)

**BLUE POODLE HOTELA.** This property was originally owned by the Rehoboth Beach Association in the 1800s. In 1884, it was sold to William Bright of Delaware, who built his house there between 1899 and 1910. The building is now one of only three original houses still standing on Delaware Avenue. In 1968, it became the Blue Poodle Hotela. Then, in 1996, Matthew Turlinski and Gerald Lynn Sipes bought the hotel and began renovations. They have given the inn a nautical theme and named each room after a town famous for its lighthouse. The inn has been appropriately renamed The Lighthouse Inn. The atmosphere is quite charming and cozy and it is still located at 20 Delaware Avenue. (Courtesy of Matthew Turlinski and Gerald Lynn Sipes.)

# *Nine*
# CHURCHES
## HALLOWED HALLS

*Religion in Rehoboth Beach has been traced back to 1873 when Rev. Robert W. Todd of the Methodist Episcopal Church in Wilmington, Delaware chose the area for his religious summer camp meetings. Reverend Todd was inspired to have a seaside location for his camp after attending a gathering on the Jersey Shore in 1872, which he claims lifted his spirits and improved his health. Land was purchased, an association was formed, and money was raised. Most of the 400 acres were quickly sold or leased to the members of the Rehoboth Beach Camp Meeting Association who then erected one-room wooden "tents." These meetings lasted from 1873 to 1881 and, during that time, the association built a tabernacle with a 500-seat capacity. The meetings did not begin again until August 17, 1895 and were led by Rev. R.H. Adams of the Dover District Methodist Episcopal Church.*

*Today, amidst the sun and fun of the Nation's Summer Capitol, six established religions have found their niche in Rehoboth. The Methodists, the first to establish their roots, opened a church in 1897. St. Agnes By-The-Sea, a Roman Catholic church, opened in 1906; a Presbyterian church came along in 1931; the Christian Church followed 16 years later in 1947; the Lutheran Church opened its doors in 1950; and in 1980 the All Saint's Church was finished.*

**ANN HAZARD MUSEUM.** This museum at 17 Christian Street was one of the "tents" used during camp meetings in the 1890s. Moved from its original location at 59 Baltimore Avenue and refurbished, it is now used by the Rehoboth Beach Historical Society. It was named after Ann Hazzard, the first female real estate broker in Rehoboth. (Courtesy of Bo Bennett.)

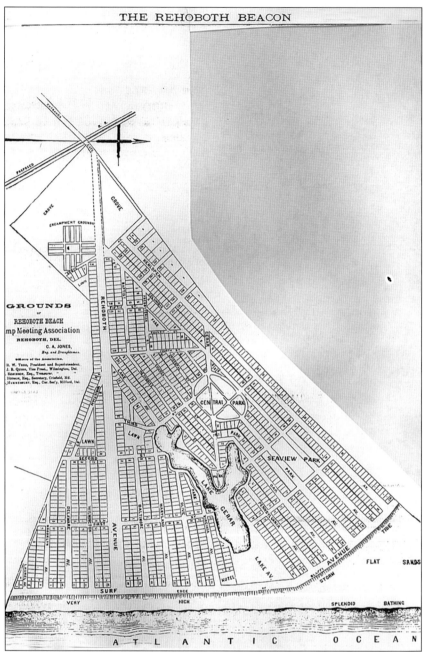

**CAMP MEETING ASSOCIATION GROUNDS.** The *Rehoboth Beacon*, published by the Rehoboth Beach Camp Association of the M.E. Church, included this map of the grounds in their first issue, dated July 1873. An article on the front page of the *Beacon* advertised the 1,000 lots, streets, and avenues that were still available and could be purchased from between $75 and $150. Followers of the gospel were given lots at a 20 percent discount from the usual rates. (Courtesy of the Rehoboth Beach Historical Society.)

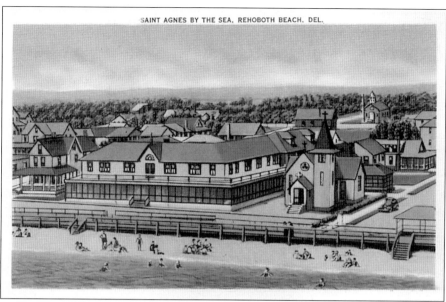

**ST. AGNES BY-THE-SEA.** This property, purchased in 1905 by the Diocese of Wilmington, included the oceanfront block between Laurel Street and Brooklyn Avenue from the Rehoboth Beach Camp Meeting Association of the Methodist Episcopal Church. A chapel, a rectory, and two cottages were established. In July 1906, a new building was erected to accommodate the growing members. St. Agnes By-the-Sea was struck by severe storms and moved further back from the beach twice during its time on this property. It was torn down in 1962 after a severe northeaster. Eventually, the land was deeded to the Franciscan Order for the Nuns, who are pictured on the porch in the postcard below. The nuns sold the property in 1946 and the Star-of-the-Sea condominiums are now on the site. (Courtesy of John E. Jacob; Publisher: Harry P. Cann & Bro. Co.; Louis Kaufmann & Sons.)

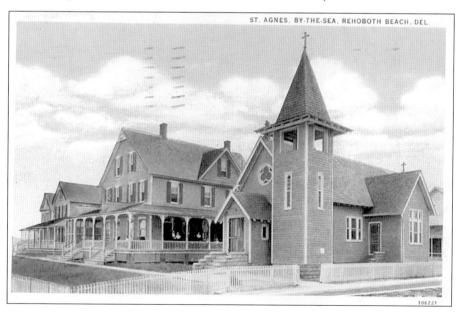

ST. AGNES, BY-THE-SEA, REHOBOTH BEACH, DEL.

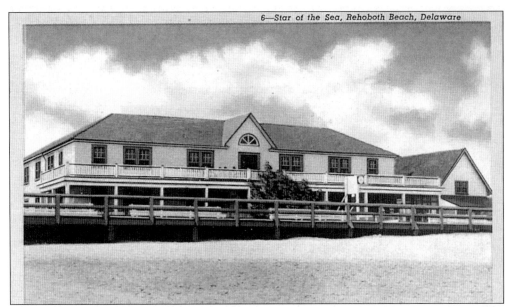

**STAR-OF-THE-SEA CONDOMINIUMS.** These condominiums were completed in 1973 on land that was once home to St. Agnes By-the-Sea. There are 96 units, each with an oceanfront view. There are commercial shops in the lobby level, a jewelry store, a sandwich shop, and a pool. (Courtesy of John E. Jacob; publisher: Harry P. Cann & Bro. Co.)

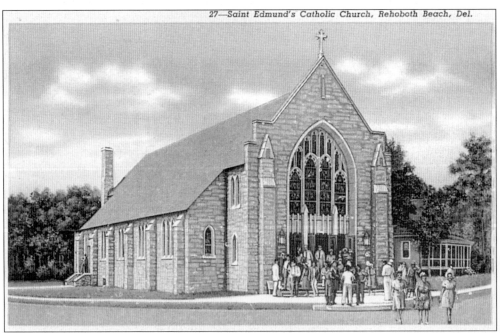

**ST. EDMUNDS ROMAN CATHOLIC CHURCH.** Built at 409 King Charles and Laurel Avenue in 1939 to meet the needs of the growing Catholic population, the church was named for Rev. Edmund Fitzmaurice, fourth bishop of Wilmington. The first mass was held in 1940. In 1952, an elementary school was built next to the church. Nuns taught children until 1969 when the school closed. (Courtesy of John E. Jacob; publisher: Harry P. Cann & Bro. Co.)

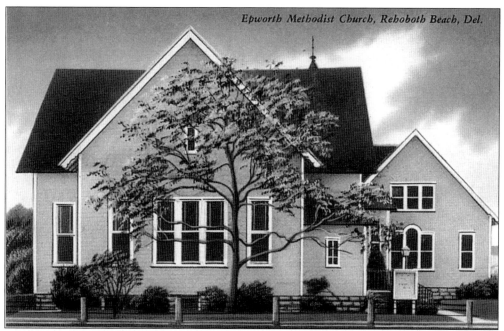

*Epworth Methodist Church, Rehoboth Beach, Del.*

**EPWORTH METHODIST CHURCH.** Originally located at the corner of Rehoboth and Lake Avenue in 1898, Epworth Methodist Church has moved twice since opening. It first moved to 20 Baltimore Avenue in 1914; classrooms were added in the early 1940s for Sunday school. In 1960, the church moved again, this time to 36 Baltimore Avenue, where a new sanctuary and educational building were added. The pastor today is Rev. Anne Pruett-Barnett who enjoys ministering to 400 members. (Courtesy of John E. Jacob; publisher: Tingle Print Company.)

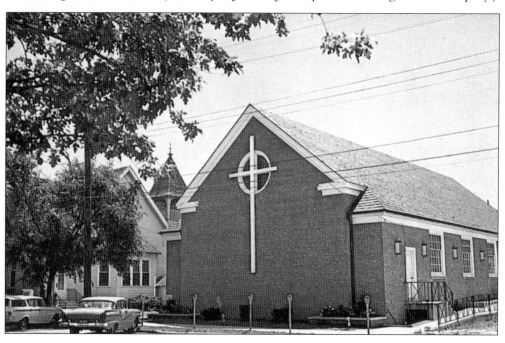

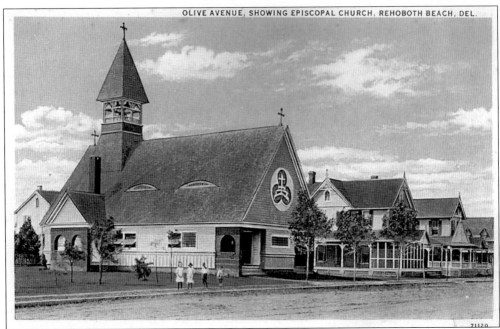

**ALL SAINTS CHURCH.** This church was built in 1893, remodeled in 1937, and remodeled again in 1958. The parish endured two fires that ruined the interior, which is probably why the spire has changed from the early postcard to the postcard below. (Courtesy of John E. Jacob; publisher: Tingle Print Company and Louis Kaufmann & Sons.)

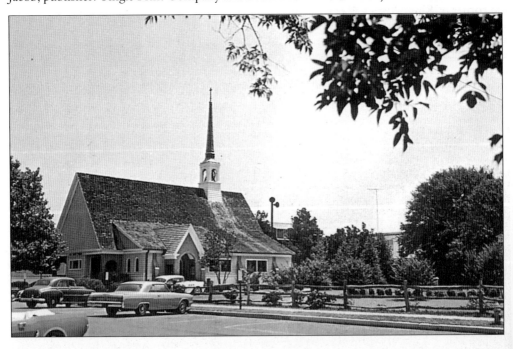

**WESTMINSTER PRESBYTERIAN CHURCH**. All visitors are welcome to this Colonial-style church, founded in 1921. The postcard was sent with a 2¢ stamp from a woman who declared that the minister "must have been from Boston as he talked differently from us." Located on the corner of King Charles Avenue and Laurel Street, one block from the ocean, the church serves about 120 parishioners in the summer. Today, the pastor is Rev. John Dean, who first arrived in Rehoboth in 1965. The postcard below shows that little structural change has occurred since the early 1900s. (Courtesy of John E. Jacob; publisher: Tingle Print Company.)

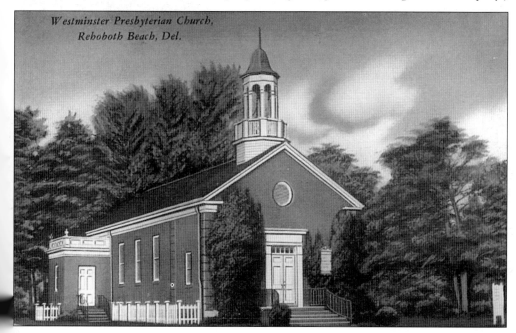

# BIBLIOGRAPHY

Below are some of the many sources we used in writing this book. We thank any source we may have overlooked.

Bridges, Ted. "Parakeets Remain on Silver Lake." *Delaware Coast Press*. July 19, 2000.

Delaware State Planning Office. "Historical Analysis." 86.9. From *Transportation and Land Use Studies*, February 1968, pp 27–32.

Floor, Bill. "Resorts Push Comeback." *The Evening Journal*. Wilmington, Delaware: 1962.

Frank, Bill. " . . . Beach—Before and After." *The Evening Journal*. Wilmington, Delaware: 1962.

———. "There'll Always be a Rehoboth." *The Evening Journal*. Wilmington, Delaware: 1962.

Hillis, Roger. "Rehoboth Restaraunt Owners Feed Famous." *Delaware Coast Press*.

Limpert, Jack. "Washington's Guide to Rehoboth Beach." *The Washington Post*. June 1976.

Meehan, James D. *Rehoboth Beach Memories: From Saints to Sinners*. Published by Harold E. Dukes Jr.

Shortbridge, Dan. "Cape Lighthouse Will Cost $10M to Build." *The Daily Times*. Summer 2000.

Skelly, Heather ed. *Traveller*. Delaware River and Bay Authority. Wilmington, Delware: publisher Brad Hawkins.

Stevenson, Jay. *Rehoboth of Yesteryear*. Georgetown, Delaware: Rogers Graphics Inc.

Thorne, Christopher. "More to Rehoboth than Meets the Eye." *Associated Press*. June 19, 2000.

Terrell, Dan. *Room for One More Sinner*. 2nd Edition, 1984. Dan Terrell.

Wellburn, Margaret. "Down Memory Lane." *The Beacon*. Vol. 2, No. 3, October 1980.

# OTHER SOURCES

Bethany-Fenwick Area Chamber of Commerce.

Broadbent, Alan. postcards, photographs, newspaper clippings, interviews.

The Catholic Church In Reboboth Beach & Lewes, Delaware (Pamphlet).

Chesapeake Bay Bridge-Tunnel Authority.

Delaware Tourism Office.

Delaware River & Bay Authority.

Jacob, John of Salisbury, Maryland. postcard source.

Lewes Chamber of Commerce and Visitors Bureau.

Lewes-Rehoboth Chamber of Commerce.

The Rehoboth Beacon.

Rehoboth Beach-Dewey Beach Chamber of Commerce

The Rehoboth Beach Historical Society.

Rehobeth Outlets.

# INTERVIEWS

Interviews and information came from the following people:
Ashley, Lanman—Rehoboth Beach Police Department; Barrows, Ron—Rehoboth Beach Country Club; Beach, Jack; Broadbent, Alan—Melbourne, Florida; Browse About Books; Buckson, Kent—Captain of the Rehoboth Beach Patrol; Charles, Gina and Carol Everhart—Chamber of Commerce Rehoboth Beach; Foley, Tim—ReMax ; Derrickson, Don—Sandcastle Motel; Feeney, Bob—Old Landing Golf Course; Ferrese, Gregory—City Manager of Rehoboth Beach; Hackett, Marilyn—Rehoboth Library; King, John F.W.—Ho-Ho-Kaus, New Jersey; Lattinville, Jeff—Atlantic Sands Hotel; Lingo, Carol—St. Edmunds Catholic Church; Moore, Chad—Dinner Bell Inn; Schaefer, Abby—Special Olympics; Simpler, Irene; Sipes, Jerry and Matt Turling—Lighthouse Inn; Sturdavant, Gail—Westminster Presbyterian Church; Summers, Tom—Delaware Public Archives; Mrs. Thoroughgood; Tubbs, John T.; Yaksic, George—Star-Of-The-Sea Condominiums.

# INTERNET

"At the Beach." [Bethany Beach, Delaware City Guide and Regional Information]
www.bethanybeachde.com

Bethany Harold. "History of Bethany Beach. 1904"
www.bethanybeach.com/history.html

"Map: at the beach." www.atbeach.com

Delaware State Archives, Dover, Delaware

"Rehobeth Beach, the Community." [Town History and Landmark Dates]
www.rehobeth.com/landmarkdates.asp

"Rehobeth Beach, the Community." [Town Early History]
www.rehobeth.com/earlyhistory.asp

Delaware Historical Society—www.state.de.us

"Rehobeth Beach, the Community." [General City and Beach Information]
www.rehobeth.com/citygerneral.asp

"Rehobeth Beach Main Street." [Beach Main Street]
www.rehomain.com/mainstreet.asp

"Rehobeth Beach, What to Do." [Festivals] www.rehobeth.com/festivals.asp

"Rehobeth Beach-Dewey Beach Resort Area Sights & Sounds." [Rehobeth Beach
Dewey Beach Chamber of Commerce.] www.beach-fun.com/index.html

"Rehobeth Beach, What to Do." [Beaches and Parks]
www.rehobeth.com/beaches.asp

http://www.beach-fun.com/index.html

Google.netscape.com/netscape?/quety=Bethany+Beach+DE+history

Townofbethanybeach.com/history

www.realtor.com/sussex/gailsturdvant

www.starofthesea-de.com

www.lighthouseinn.com

www.rehobothpolice.org

www.rehobothbeachpatrol.com